IMAGES
of America

NORTH
HEMPSTEAD

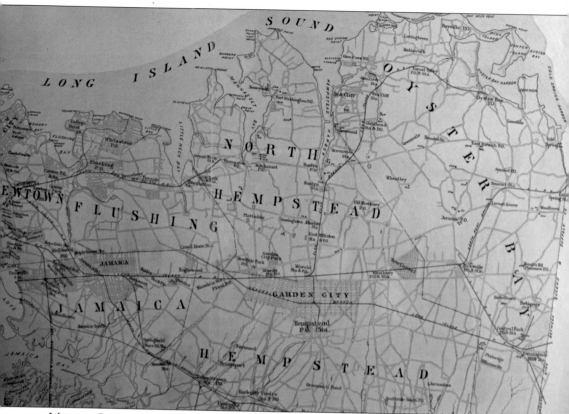

MAP OF QUEENS COUNTY, CHESTER WOLVERTON, 1891. The current boundaries of North Hempstead are virtually unchanged since the town separated from Hempstead in 1784 and when it was part of Queens County until January 1, 1899. The northern peninsulas of Great Neck and Manhasset Neck (Cow Neck) are bounded by Little Neck Bay, Long Island Sound, Manhasset Bay, and Hempstead Harbor. The west boundary is the Queens border, and the east boundary is the town of Oyster Bay. The southern boundary is the town of Hempstead, with a large section of the border being Old Country Road. This map, by Chester Wolverton, is from North Hempstead's Queens County era. (Courtesy of Town of North Hempstead Archives.)

IMAGES
of America

NORTH
HEMPSTEAD

Howard Kroplick
Foreword by Leslie Gross

ARCADIA
PUBLISHING

Published by Arcadia Publishing
Charleston, South Carolina

Printed in the United States of America

Library of Congress Control Number: 2013935453

For all general information, please contact Arcadia Publishing:
Telephone 843-853-2070
Fax 843-853-0044
E-mail sales@arcadiapublishing.com
For customer service and orders:
Toll-Free 1-888-313-2665

Visit us on the Internet at www.arcadiapublishing.com

To Roz Kroplick, my partner and love of my life.

CONTENTS

FOREWORD

North Hempstead's splendid past is brought to life in the following pages, written by our dedicated town historian, Howard Kroplick.

Prepare to be transported back in time, to when the North Shore of Long Island was known as the Gold Coast, a diverse area of communities less than 20 miles from Manhattan, each enriched by unique inhabitants.

As town clerk of North Hempstead for the past six years, it has been my passion to explore our rich history. In this role, I am charged with the responsibility of preserving the history of the town for future generations. Together, Howard Kroplick and I have learned about the incredible people who shaped our past and created what we know today as the town of North Hempstead, currently home to 239,000 residents.

We welcome you to share the treasures we have uncovered. May our passion for the past give you a greater sense of our path to the present!

—Leslie C. Gross, MMC
Town clerk of the Town of North Hempstead

ACKNOWLEDGMENTS

In celebration of North Hempstead's first inhabitants and the 400th anniversary of the first European to explore its shores, over 200 vintage images, historic documents, and maps have been obtained from town and village archives, historical societies, schools, universities, museums, and private collections throughout Long Island.

Thanks so much to town clerk Leslie Gross, town photographer John Meehan, and town archivist Dr. Jack Binder for their assistance in obtaining information and access to the Town of North Hempstead Archives.

I would also like to thank the unknown amateur and professional photographers who captured these images so many years ago, and the following people who made contributions to this book: Jonathan Aubrey, Chris Bain, Fernanda Bennett, Ellen Birnbaum, Eleanor Boyle, Linda Brickman, Dr. Irmgard Carras, Mother Margaret Clark, Natasha Walia Commander, Kathy Curran, Glen DeSalvo, Rhianna Ellis, Chris Filstrup, Orrie and Goodie Frutkin, Richard Gauchot, Walt Gosden, Stephanie Gress, Marianne Howard, Jerry Helck, Town of North Hempstead supervisor Jon Kaiman, Joan Kent, Gary Lawrance, Iris Levin, Mayor Dan Levy, Robert McKay, David Bunn Martine, Gordon Miller, Virginia Murray, Kristen Nyitray, Natalie Naylor, Franklin Hill Perrell, Catherine Pickering, Jim Procopio, Don Rittner, Bob Russell, Sally Soltirovich, John Santos, Jonathan Sherman, Myrna Sloam, Joshua Stoff, Dr. John Strong, Lauren Summa, Al Velocci, Debbie Wells, and Ian Zwerdling.

I would like to thank these organizations, who also made contributions to this book: Brown University, Bryant Library, Company K-67th New York Volunteer Infantry, Cradle of Aviation, Cow Neck Peninsula Historical Society, Getty Images, Great Neck Library, Hempstead Post Office, Library of Congress, Manhasset Public Library, Nassau County Department of Museum Services, Nassau County Museum of Art, New-York Historical Society, New York State Parks, Port Washington Library, Queens Borough Public Library, Roslyn Landmark Society, Roslyn Public Schools, University of Illinois at Urbana–Champaign, SPLIA, Stony Brook University, Suffolk County Historical Society, Suffolk County Vanderbilt Museum, The Metropolitan Museum of Art, Trinity Episcopal Church, UCLA Department of Geography, and Wikipedia.

Thanks to Abby Henry, the Arcadia Publishing editor for this book, for her encouragement and helpful communications.

I extend special appreciation to my wife, Roz, and our daughters, Dana and Deborah, for their suggestions, editing, and comments, and to John Cuocco for his wonderful research assistance.

Unless otherwise noted, the images are from the collection of Howard Kroplick.

INTRODUCTION

The history of North Hempstead begins with the creation of Long Island over 40,000 years ago. Geologists believe huge glaciers, two miles thick, pushed ice and earth south across Canada and northern America. Around 20,000 years ago, the last glacier came to a halt on Long Island as it reached warmer ocean currents. As the glacier gradually melted, the sea level rose and the Long Island Sound was formed. These glaciers also created Long Island's 120-mile-long fish shape, lakes, rivers, the hills and harbors of the North Shore, and the flatlands and bays to the south. Dramatic changes were also occurring on land, as forests, fish, shellfish, and wildlife flourished.

Archeologists believe that the first explorers of Long Island may have migrated over the Bering Strait land bridge or traveled by boats from Asia over 8,000 years ago. Little is known about these people who came to hunt and left little trace of their lives. About 3,000 years ago, the native people of this area established permanent village communities on the banks of freshwater streams that flowed into the bays, abundant with fish and shellfish. They harvested food from the plains and forests and used baked pottery vessels. Over 1,000 years ago, a new population, identified by archaeologists through their distinctive pottery, inhabited the area. These people lived in the western part of Long Island and coexisted with the communities that lived farther to the north and east. Major changes included new styles of projectile points, the establishment of permanent settlements, and new religious rituals. Evidence has been found that their house structures were circular and oval-shaped dwellings as large as 600 square feet. A few of their characteristic fluted points, knives, scrapers, and drills have been discovered in North Hempstead.

Since the natives had no written language for thousands of years, the documented history of North Hempstead began when Dutch navigator Adriaen Block discovered the Long Island Sound in 1614. Giovanni de Verrazzano had visited New York Bay 90 years earlier without recognizing the Long Island Sound. Based on Block's explorations, the Dutch claimed Manhattan and western Long Island. In 1643, a small group of English settlers led by Rev. Robert Fordham and his son-in-law John Carman crossed the Long Island Sound from Stamford, Connecticut, and attempted to establish a settlement on Long Island. On December 13, 1643, they negotiated a treaty with Tackapausha, sachem leader of the Marsapeagues, and six other leaders to purchase all the land within the present towns of North Hempstead and Hempstead. For the next 141 years, the two towns would be one entity, called Hempstead, named for the settlers' ancestors' English village of Hemel-Hempstead. In November 1644, Fordham and Carmen secured the necessary permission "patent," or Conformation of Purchase, with the Dutch governor, William Kieft, who wished to develop the area with settlements.

The British ousted the Dutch from New Amsterdam in 1664 and established New York colony. One year later, the small hamlet of Hempstead hosted the first colonial convention. Leaders adopted the "Duke's Laws," which established basic principles of law and local government, and a constitution was approved. In 1683, Gov. Thomas Dongan called for a representative assembly, which created the counties of New York State. Present-day North Hempstead and Hempstead were part of Queens County, which also included Queens and Oyster Bay.

By 1774, discontent with English rule throughout the colonies along the Atlantic coast became widespread, as laws were passed to increase taxes and regulate trade. As the revolutionary fervor mounted, a wide division separated the town of Hempstead among Loyalists supporting the British, Patriots supporting independence, and neutrals, who hoped war could be averted. Many residents living in the southern section of town near Hempstead did not support a revolution and remained loyal to the British cause and King George III. The farmers of the northern "Necks" and families of the original Dutch settlers had closer ties with New England and supported breaking from British rule. It came to a head on April 4, 1775, when the Hempstead Town Board, controlled by Loyalists, resolved to "true and faithful allegiance to His Majesty King George the Third, our gracious and lawful Sovereign." The board refused to send a delegate to the Provincial Congress in New York City seeking to create an alternative government.

Outraged by the strong loyalist stance of the town, the leaders of Great Neck and Cow Neck (Port Washington/Manhasset) issued their own declaration of independence from the Town of Hempstead on September 23, 1775. They declared, nine months before the nation's Declaration of Independence: "their general conduct is inimical to freedom, we be no further considered as part of the township of Hempstead than is consistent with peace, liberty, and safety; therefore in all matters relative to the congressional plan, we shall consider ourselves as an entire, separate and independent beat or district." The document was signed by John Farmer, clerk of the meeting. Great Neck and Cow Neck patriots listed on the document included John Burtis, John Cornwell, W. Cornwell, Thomas Dodge, Daniel Kissam, Daniel Whitehead Kissam, John Mitchell, Adrian Onderdonck (who would become the first town supervisor of North Hempstead), Petrus Onderdonck, Benjamin Sands, Simon Sands, Martin Schenck (treasurer of Queens County in 1786 and 1792), Henry Stocker, and William Thorne.

Just eight weeks after the Declaration of Independence, the largest engagement occurred in Staten Island, Brooklyn, and Manhattan. Gen. William Howe led nearly 20,000 British soldiers and Scottish and Hessian auxiliaries and 400 ships against Washington's army. The Battle of Long Island was the first conflict for the United States as an independent nation. Washington, outnumbered two to one, suffered a severe defeat as his army was outflanked. His army scattered and retreated to Brooklyn Heights. The Americans escaped to Manhattan via the East River and then evacuated the city. Following the Battle of Long Island, North Hempstead and New York City would be occupied until the Treaty of Paris was signed on September 3, 1783. British troops would finally evacuate New York City and Long Island on November 25, 1783.

Seven months after the war ended, on April 6, 1784, the New York State Legislature granted North Hempstead's request to become a separate town. The "act to divide the township of Hempstead" was signed by George Clinton, the first governor of New York State and, later, the first elected vice president of the United States. The first town board meeting was held in the home of Samuel Searing in Searingtown on April 14, 1784. Patriot Adrian Onderdonck was selected as the first town supervisor.

A citizens' meeting on January 22, 1898, set the stage for the secession of the three towns, North Hempstead, Hempstead, and Oyster Bay, from Queens County by proposing the creation of a new Nassau County. After a bitter battle in Albany, the law creating Nassau County was signed by Gov. Frank S. Black on April 27, 1898, to take effect on January 1, 1899.

After the first town meeting in 1784, board and town meetings were held at the homes of board members and rotated among town inns, taverns, and hotels. Vital records were stored in the home of the town clerk. On March 4, 1905, the town finally approved $20,000 to build a town hall and vaults for the storage of records. On May 23, 1905, after five ballots, a Plandome Road site in Manhasset was selected over Roslyn and Mineola for the new town hall. On October 16, 1907, the dedication ceremony was attended by community leaders and town residents and was hosted by town supervisor Philip J. Christ.

For over 200 years, the harbors and bays of North Hempstead and the Long Island Sound supported a thriving maritime economy of fishermen, boatbuilders, and sailmakers. Shellfishing was important to the economy of Port Washington and Roslyn as early as 1832, when Henry Cocks, owner of a Manhasset Bay tidal mill, planted oysters in a saltwater pond. In 1855, a group of Staten Island businessmen invested in planting oysters in Cow Bay (Manhasset Bay), leading the development of commercial oyster farming in Manhasset Bay and Hempstead Harbor. The result was an influx of new families to North Hempstead. Shellfish buyers from New York City arrived, first by sloops on the Long Island Sound, to the ports in Roslyn and Port Washington. When the railroad station opened in Port Washington, barrels were shipped by train to the markets. In 1880, a US Fish Commission study referred to Port Washington as "the seat of a very large oyster industry." During this time, 200 of the 320 Port Washington registered voters listed their occupations as oystermen. The shellfishing industry in North Hempstead came to an end in the early 1900s as the Long Island Sound became polluted with untreated sewerage. Hempstead Harbor was officially closed for shellfishing in 1966. With the elimination of many industrial uses around the harbor and water-quality improvement

efforts, the New York State Department of Environmental Conservation in June 2011 opened 2,520 acres of outer Hempstead Harbor as a shellfish area.

Pasturing cattle in North Hempstead began soon after the initial settlement was established by Foreman and Carmen in 1643. The settlers established farms on the Hempstead Plains and pastured their cattle on the hilly Cow Neck peninsula, which had an abundant supply of water. The importance of cattle farming in early North Hempstead is shown in the town archives. On May 2, 1654, the town board required that "Ye Inhabitants" with rights in "ye neck" shall fence in the property or "pay for every rodd defective twoe shillings and sixpence." The rich soil and meadows of North Hempstead, fed by springs and ponds, helped make farming the primary occupation through the 1800s. Farmers grew vegetables and wheat, kept chickens, hens, and cows, and bred horses for transportation. Many raised sheep for wool. Through the 1800s, most of the property surrounding Hempstead Harbor was occupied by farms on rolling hills owned by families of the original North Hempstead settlers. Eventually, most of this area was sold to sand-mining companies, which mined the vast deposits of glacial sand and gravel laid down over 20,000 years ago. Between 1865 and 1989, more than 200 million tons of sand were shipped from Port Washington to New York City to make concrete for skyscrapers, subway tunnels, foundations, and sidewalks. An estimated 90 percent of all the concrete used to build New York City came from these sandpits.

As demand increased for bringing goods and people to New York City, steamboats began to travel to Port Washington, Sands Point, Great Neck, and Roslyn. The North Shore Railroad extended its Flushing line to Great Neck in 1866. In the mid-1870s, the branch became part of the Long Island Rail Road, which built its first Great Neck station in 1883. Trains ran to Long Island City, where passengers would board ferries across the East River to Thirty-fourth Street in Manhattan. As a result of the new train station, businesses grew in the southern section of the village, now known as Great Neck Plaza. With the completion of the railroad tunnel in 1910, the Great Neck commute became even more attractive. From 1908 to 1926, William K. Vanderbilt Jr. and his business associates built the first road specifically for the automobile. Of the 44-mile concrete road on Long Island, 14 miles would be built in North Hempstead, helping to transform rural farmland into sprawling suburbs. The large, protected body of water and proximity to New York City and Long Island plane manufacturers made Manhasset Bay a mecca for seaplanes through the 1930s. On June 28, 1939, the first commercial passenger transatlantic flight was made by a Pan Am Boeing 314 "Dixie Clipper" carrying 22 passengers from Port Washington to Lisbon, Portugal, with one stop in the Azores.

When trains and automobiles reduced the commute to Manhattan to less than one hour, wealthy New Yorkers sought out North Hempstead to escape busy city life. In the early 1900s, the North Shore of Long Island became known as the Gold Coast. The area had the highest concentration of wealth in the country. The rich and famous flocked to the area and built grand homes and estates. Sporting events entertained high society and town residents, such as the historic Vanderbilt Cup Races, polo, fox hunting, and golf.

There are hundreds of historic sites, buildings, and districts throughout North Hempstead. The appearance and architectural integrity of 17 of these landmarks and districts are currently designated by the town's Historical Landmark Preservation Commission for legal preservation and protection. The designated town landmarks include 11 buildings, 3 cemeteries, 2 historical districts, and a boulder.

The town of North Hempstead continues to evolve and change. The greatest changes have occurred over the last 100 years as a result of progress in transportation. In 1900, the town's population was only 12,048, with farming and sand mining the major occupations. With the extension of the Long Island Rail Road, availability of affordable automobiles, and improved roads and parkways, the town became a commuter haven by 1950, with a population of 142,613. Over the next 50 years, the sprawling suburban communities of the town continued to boom. The population increased by over 56 percent, reaching 226,322 people in 2010. The appeal and attractiveness of the town was highlighted in a recent *Money* magazine article ranking North Hempstead No. 46 in its listing of the "Best 100 Places to Live in America."

One

EVOLUTION OF THE TOWN

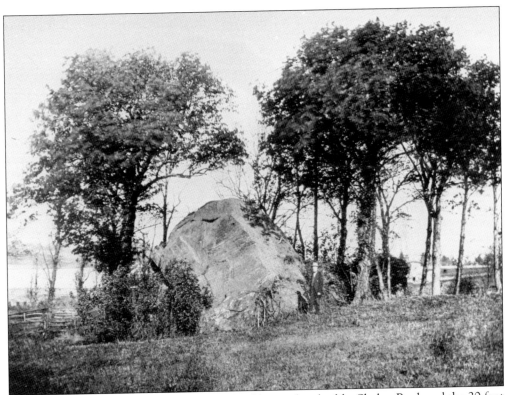

"BIG ROCK," C. 1880. Glaciers left behind boulders and rocks, like Shelter Rock and the 20-foot "Big Rock" in Plandome Heights (seen here). A man and his dog can be seen at the base of the boulder. This boulder, on Shore Road, was demolished by a developer years ago. (Courtesy of Town of North Hempstead Archives.)

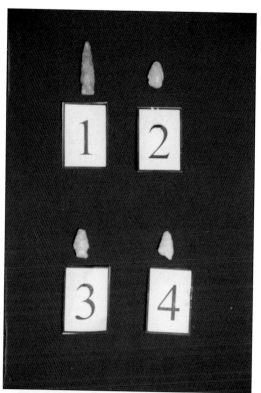

LAKE SUCCESS ARROWHEADS, C. 1910.
These projectile points were found on John Dennelly's farm (seen below) in the early 1900s and were recently identified by Prof. John Vetter of Adelphi University. The quartz points were used for spear-throwers, axes, drills, utensils, and tools for making shelters and canoes. (Courtesy of Town of North Hempstead Archives.)

MAPLE COTTAGE. This house was built in Lake Success in 1814 by Sam Warren. In the 1870s, the Warren farm was purchased by John Dennelly, who previously lived in Great Neck and owned a landscape business. Maple Cottage was the first house in Great Neck to have indoor plumbing and electric lights. The arrowheads seen at the top of this page were found on this farm.

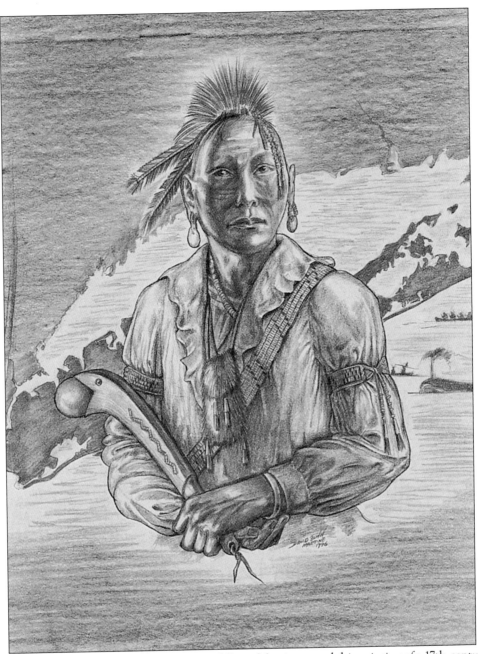

ALGONQUIAN MAN. Shinnecock artist David Bunn Martin created this painting of a 17th-century Algonquian man, whose tribe encountered the first European settlers in the early 1600s. The work was based on details observed at the Smithsonian's National Museum of American History, including a 17th-century colonial shirt, the wampum bandoleer across his shoulder, a tobacco pouch of squirrel skin, and the leather armbands decorated with porcupine quill. The headdress was made from deer hair, hawk feathers, and porcupine quill. When first encountered by European settlers in the 1640s, the Algonquian population on Long Island was estimated to be in the thousands. The introduction of diseases from the European settlers decimated their population. (Courtesy of David Bunn Martine and Dr. John A. Strong.)

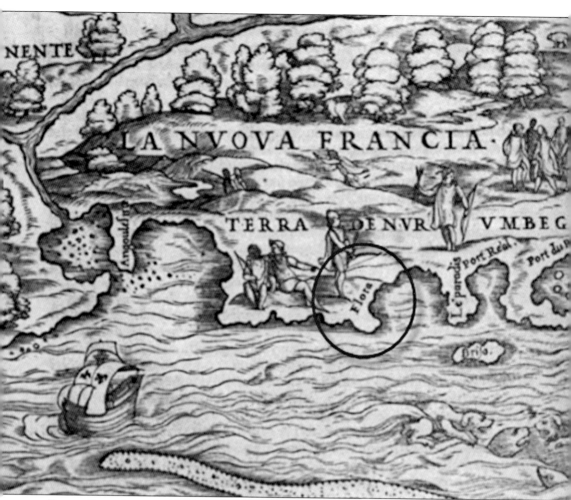

FLORA, LONG ISLAND, 1556. In the 1520s, Italian navigator Giovanni de Verrazzano explored the North American continent for France. In 1524, he and his crew discovered New York Bay. However, he missed the Long Island Sound by sailing along the South Shore of Long Island. Verrazzano believed that Long Island was a peninsula, which he named Flora. It appeared in this 1556 map of New France by Giacomo di Gastaldi. (Courtesy of John Carter Brown Library at Brown University.)

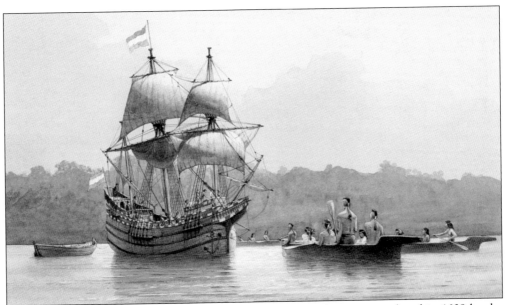

HENRY HUDSON'S HALF MOON. English explorer Henry Hudson was employed in 1609 by the Dutch to discover a northern passage to Asia. He reached New York Bay and sailed up the river bearing his name to the site that became Albany. In September 1609, his crew may have been the first Europeans to set foot on Long Island, when the *Half Moon* landed at Coney Island. But again, Hudson missed the Long Island Sound and the area that would become North Hempstead. (Courtesy of Town of North Hempstead Archives.)

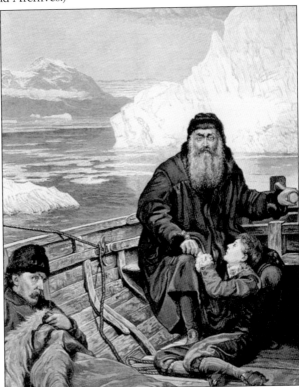

HUDSON'S LAST VOYAGE. Henry Hudson sailed again in 1611, on the ship *Discovery*, without ever recognizing the Long Island Sound. During this voyage, he discovered Hudson's Bay in present-day Canada and claimed it for England. Following Hudson's decision to continue exploring after a harsh winter, his crew mutinied and cast him adrift. Hudson, his son, and seven others were never seen again. (Courtesy of Town of North Hempstead Archives.)

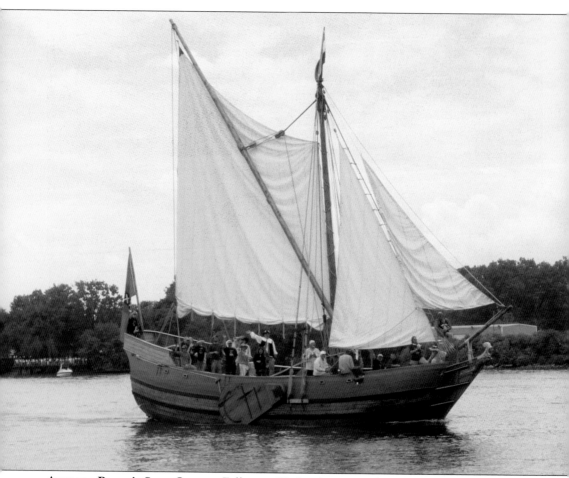

ADRIAEN BLOCK'S SHIP, ONRUST. Following Hudson's voyage, the Dutch West India Company sent Dutch navigator Adriaen Block to search for trading sites. After his ship burned, Block built another ship, *Onrust* (Restless), in Manhattan. In the spring of 1614, ninety years after the discovery of New York Bay, Block crossed the narrows in the East River and became the first European to enter the Long Island Sound. He viewed the North Shore of Long Island and present-day North Hempstead and sailed by the Connecticut River. Block is credited with determining that Manhattan and Long Island are islands and for using the term *New Netherland* on his 1614 chart. In honor of Block being the European discoverer of Long Island, Block Island on the sound was named in his honor. As seen here, a 50-foot, full-scale replica of *Onrust* took part in the 2009 commemoration of the 400th anniversary of Henry Hudson's arrival in New York. The 400th anniversary of Block's discovery will be celebrated in 2014. (Courtesy of Don Rittner.)

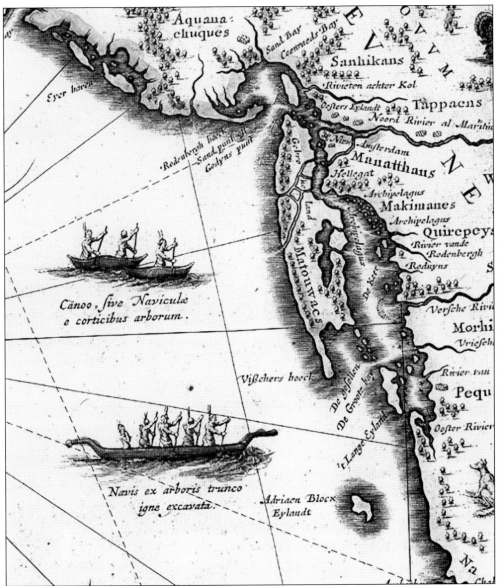

MAP OF LONG ISLAND, 1635. The general appearance of Adriaen Block's first chart of Long Island is seen in this map by William Janzoon Blaeu, the head of a family of Dutch mapmakers. A few notable place-names on the map are Manhates (Manhattan), Hellegat (Hell Gate), Hoek van de Visschers (Point of the Fishers, for Montauk Point), and Adrian Blocks Eylandt (Block Island). The name Matouwacs may have been a native term used to identify Long Island. At least one neck of North Hempstead appears to be depicted. Based on Block's explorations, the Dutch claimed Manhattan and western Long Island. After 30 years of occupation since 1614, the Dutch population had not spread much past Brooklyn. The Dutch governor, William Kieft, encouraged development of settlements, even if they were English ones. (Courtesy of Stony Brook University.)

17

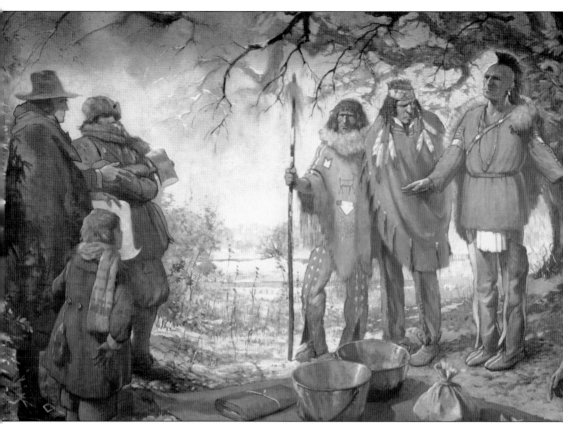

THE FIRST REAL-ESTATE TRANSACTION IN HEMPSTEAD DECEMBER 13TH, 1643. In 1643, a small group of English settlers, led by Rev. Robert Fordham and his son-in-law John Carman, crossed the Long Island Sound from Stamford, Connecticut, and attempted to establish a settlement on Long Island. On December 13, 1643, they negotiated a treaty with Tackapausha, sachem leader of the Marsapeagues, and six other leaders, Aarane, Pamaman, Remoj, Waines, Whanage, and Yarafus, to purchase all the land within the present towns of North Hempstead and Hempstead. The transaction is documented in this 1947 mural by Robert Gaston Herbert (1873–1954). It hangs in the Hempstead Village Hall. (Courtesy of Village of Hempstead.)

ENGLISH SETTLEMENT DEED CONFIRMED ON JULY 4, 1657. The 1643 deed to the English settlement was officially confirmed in 1657. It reads, "Know all men by these presents: That wee the Indians of Marsapege, Mericoke and Roakawy whose names under written, For ourselves And all ye rest of ye Indians that doe claime any righte or Interrest in the purchase that Hempsteede bought in the yeare 1643." The marks of nine leaders, including "Takapasha—the Sacham of Marsapeague" and "Wantagh—the Mantoake of Sacham," appear on this original document, which is stored in the town archives. (Courtesy of Town of North Hempstead Archives.)

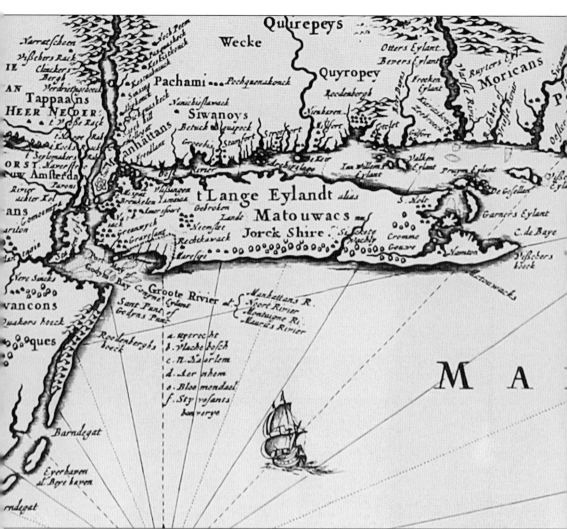

JANSSON-VISSCHER MAP, 1656. The Dutch makers of this map understood that t'Lange Eylandt was not an archipelago. The name Matouwacs is noted as an "alias" for Long Island. The name around Hempstead is Gebroken Landt ("broken up land"). The dotted area appears to be the first mapping of the Hempstead Plains, indicating the importance of sheep and cattle raised on "America's first prairie." (Courtesy of Stony Brook University.)

THE DUKE'S LAWS, 1665. The British ousted the Dutch from New Amsterdam in 1664 and established New York colony. In 1665, the small hamlet of Hempstead hosted the first colonial convention. Leaders adopted the Duke's Laws, which established basic principles of law and local government, and they approved a constitution. The "Hempstead" copy of the Duke's Laws is in the town archives. (Courtesy of Town of North Hempstead Archives.)

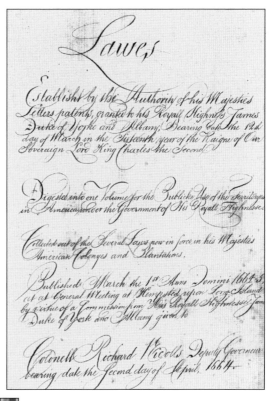

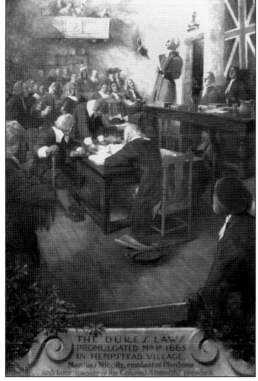

THE DUKE'S LAWS, MARCH 1, 1665. This mural of the Duke's Laws convention was created in 1937 by Robert Gaston Herbert of Sea Cliff, under the auspices of the Works Progress Administration (WPA). The four Herbert murals were placed in the rotunda of the Nassau County Old Courthouse, now the Theodore Roosevelt Executive and Legislative Building in Mineola. (Courtesy of Jonathan Sherman.)

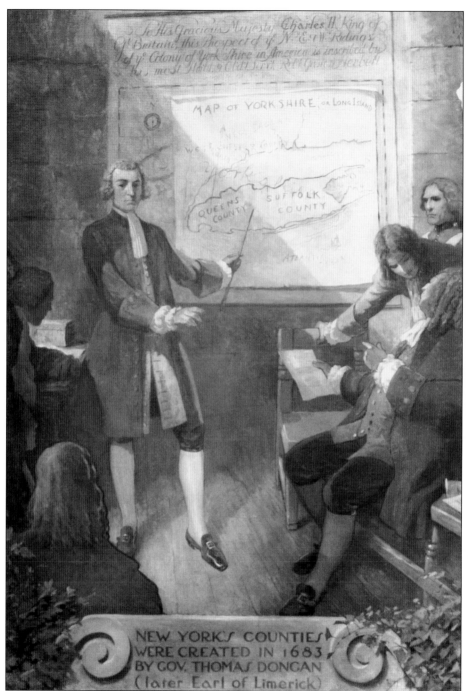

NEW YORK'S COUNTIES CREATED IN 1683. Gov. Thomas Dongan called for a representative assembly, which created the counties of New York State. Long Island was divided into three counties: Kings, Queens, and Suffolk. Present-day North Hempstead and Hempstead were part of Queens County, which also included Queens and Oyster Bay. This 1937 Robert Gaston Herbert mural, a WPA project, was placed in the rotunda of the Nassau County Old Courthouse, now the Theodore Roosevelt Executive and Legislative Building. (Courtesy of Jonathan Sherman.)

ENGLISH SETTLEMENTS IN 1760. On September 5, 1774, the first Continental Congress convened in Philadelphia to form a government capable of governing during war. As revolutionary fervor mounted, a wide division separated the town of Hempstead among Loyalists, who supported the British; Patriots, supporting independence; and neutrals, who hoped war could be averted. (Map by Myrna Turtletaub; courtesy of Town of North Hempstead Archives.)

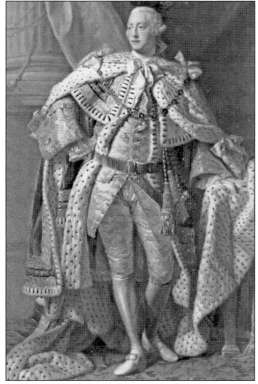

KING GEORGE III, 1762. Farmers of the northern "Necks" and families of the original Dutch settlers had closer ties with New England and supported breaking from British rule. The issue came to a head on April 4, 1775, when the Hempstead Town Board, controlled by Loyalists, resolved to "true and faithful allegiance to His Majesty King George the Third, our gracious and lawful Sovereign." (Courtesy of Wikipedia.)

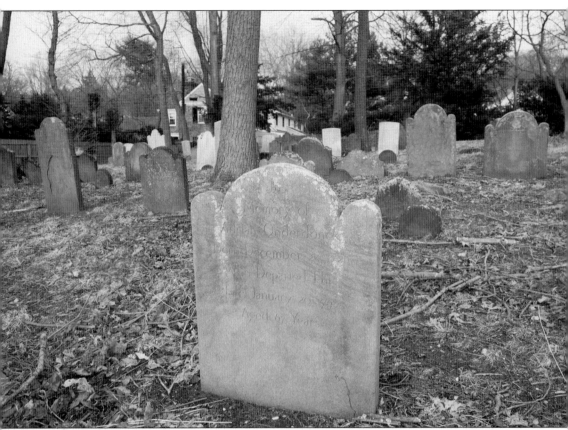

GRAVESITES OF NORTH HEMPSTEAD PATRIOTS. Outraged by the strong loyalist stance of the town, the leaders of Great Neck and Cow Neck (Port Washington/Manhasset) issued, nine months before the nation's Declaration of Independence, their intention to become independent of the Town of North Hempstead on September 23, 1775. They declared: "Their general conduct is inimical to freedom, we be no further considered as part of the township of Hempstead than is consistent with peace, liberty and safety; therefore in all matters relative to the Congressional plan, we shall consider ourselves as an entire, separate and independent beat or district." Adrian Onderdonck, Petrus Onderdonck, Martin Schenck, and Thomas Dodge are among the signers of the document who are buried in the Monfort Cemetery in Port Washington. The headstone of Adrian Onderdonck, who became the first town supervisor of North Hempstead, is seen here.

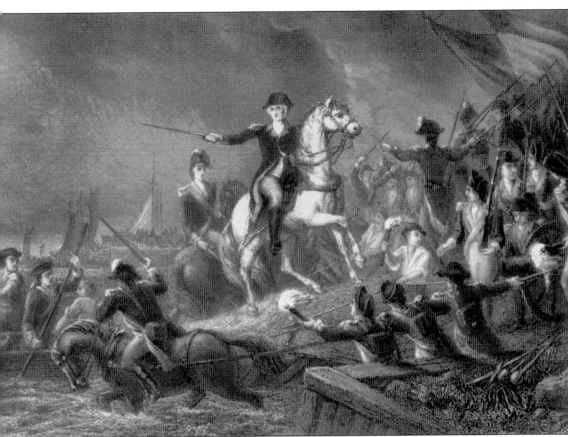

BATTLE OF LONG ISLAND, AUGUST 29, 1776. Just eight weeks after the Declaration of Independence, the war's largest engagement occurred in Staten Island, Brooklyn, and Manhattan. Gen. William Howe led nearly 20,000 British soldiers and Scottish and Hessian auxiliaries and 400 ships against Washington's army. It was the first battle for the United States as an independent nation. Washington, outnumbered two to one, suffered a severe defeat as his army was outflanked. His men scattered and retreated to Brooklyn Heights. The Americans escaped to Manhattan via the East River and then evacuated the city. This engraving, *Washington's Retreat at Long Island*, was created by James Charles Armytage (1820–1897) from a painting by Thomas Charles Wageman (1787–1863). (Courtesy of Interim Archives/Getty Images.)

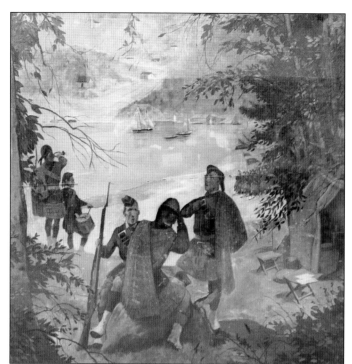

SCOTTISH REGIMENT ENCAMPED AT HEMPSTEAD HARBOR. Following the Battle of Long Island, North Hempstead and New York City were occupied until the war ended. This 1937 mural depicts a Scottish regiment encamped in Roslyn. It was one of the six WPA murals painted by Robert Gaston Herbert for the walls of the original Roslyn High School auditorium. It is currently in the lobby of the East Hills School. (Courtesy of Roslyn Public Schools.)

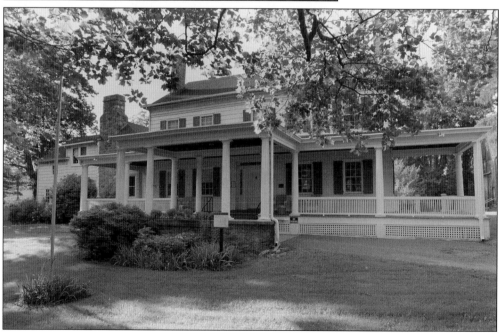

SANDS-WILLETS HOUSE, FLOWER HILL. The Sands family were merchants, farmers, and patriot leaders. They lived in this house from 1735 to 1845. Col. John Sands IV became owner in 1760. In 1775, he organized and led the Great Neck–Cow Neck–Hempstead Harbor Militia Company. Sands and his six bothers served with Washington until the war ended on September 3, 1783, with the signing of the Treaty of Paris. The house is maintained by the Cow Neck Peninsula Historical Society as a museum and educational center.

ACT TO DIVIDE HEMPSTEAD, APRIL 6, 1784. The New York State Legislature, seven months after the war ended, granted North Hempstead's request to become a separate town and officially recorded the secession. The act described the town boundaries as follows: "south of the country road that leads from Jamaica nearly through the Hempstead Plains to the east thereof and be known by the name of South Hempstead; and that all the residue shall be included in one township and hereafter called and known by the name of the township of North Hempstead." The "country road" referred to in the document is Old Country Road, which remains the primary north/south boundary of the two towns. The original document is in the town archives. (Courtesy of Town of North Hempstead Archives.)

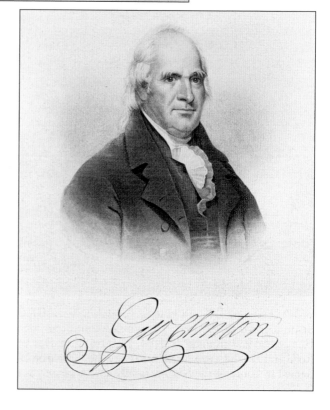

ACT SIGNED BY GOV. GEORGE CLINTON. The original document recording the division of Hempstead Township was signed by George Clinton, the first governor of New York (1777–1795 and 1801–1804). The text left his signature notes that "it does not appear improper to this Consul that the bill entitled 'An Act to divide the "Township of Hempstead" in Queens County should become a Law of this State.'" (Courtesy of Town of North Hempstead Archives.)

GOV. GEORGE CLINTON. Considered the "Father of New York State," George Clinton (1739–1812) was an ardent patriot who signed the Declaration of Independence and defended New York as a brigadier general during the Revolutionary War. In 1804, Governor Clinton became the first elected vice president of the United States and served under Presidents Thomas Jefferson and James Madison. (Courtesy of Library of Congress.)

SEARING HOUSE, SEARINGTOWN. The first town board meeting was held in this house on April 14, 1784. Patriot Adrian Onderdonck was selected as the first town supervisor. The original section of the Searing House was constructed for Samuel Searing around 1750. The house is currently a private residence and a town landmark.

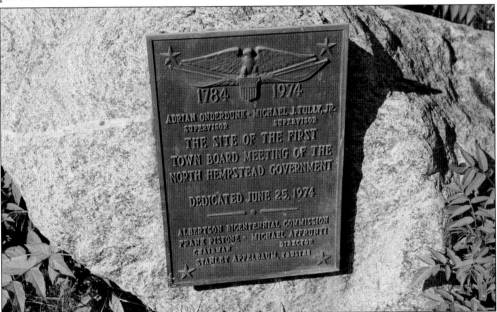

SEARINGTOWN MONUMENT. To commemorate "the site of the first board meeting of the North Hempstead government" in 1784, a historical marker was placed on the corner of I.U. Willets Road and Searingtown Road in 1974 by the Albertson Bicentennial Commission. Searingtown, named in honor of the Searing family, first appeared in the town archives in a deed dated June 6, 1768.

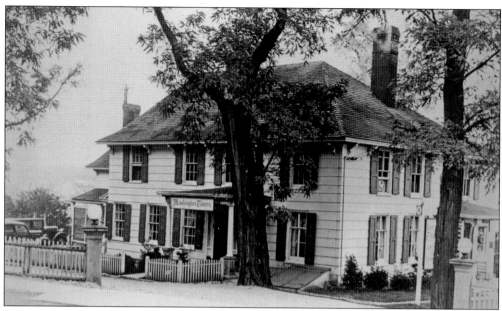

ONDERDONCK-PINE-BOGART HOUSE, C. 1928. When Pres. George Washington paid a visit to the village of Hempstead Harbor (now Roslyn) on April 24, 1790, he breakfasted at this house with its owner, Hendrick Onderdonck (Dutch spelling with the "c"). In the 1900s, the house became a restaurant appropriately named Washington Tavern, later renamed Washington Manor. Most recently, it has been restored as Hendrick's Tavern. (Courtesy of Town of North Hempstead Archives.)

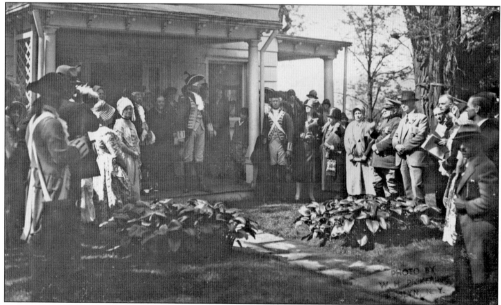

GEORGE WASHINGTON REENACTMENT, THE ONDERDONCK HOUSE. In celebration of the 150th anniversary of the inauguration of George Washington, his 1790 visit to the Onderdonck House was reenacted by history professor E.E. Wood and members of the Daughters of the American Revolution. The participants were "kindly received and well entertained" at Washington Tavern on April 29, 1939. (Courtesy of Bryant Library.)

CIVIL WAR POSTER, SEPTEMBER 17, 1862. Capt. Benjamin Willis recruited men throughout the town to join Company H of the 119th New York Regiment Infantry Volunteers. This poster to the citizens of Hempstead and North Hempstead announced a meeting at Hewlett's Hotel. "Show your Countrymen that you chose Honor and Glory before humiliation and shame." Willis successfully recruited over 100 men. (Courtesy of Town of North Hempstead Archives.)

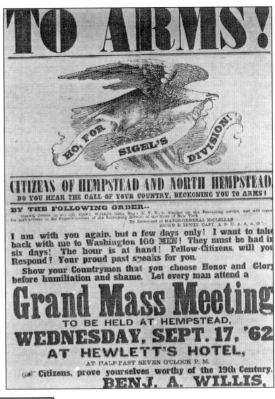

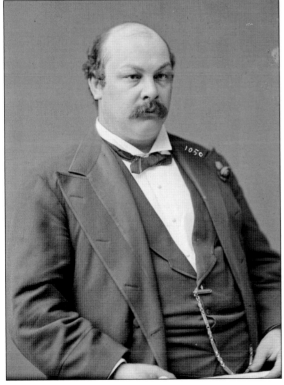

BENJAMIN A. WILLIS, C. 1864. Born in Roslyn in 1840, Willis (1840–1886) graduated from Union College in Schenectady in 1861. He then studied law and was admitted to the bar. During the Civil War, his regiment fought at Fredericksburg, Chancelorsville, and Gettysburg as well as Lookout Mountain and Missionary Ridge. After the war, Willis took up the practice of law in New York City and was later elected to two terms in Congress from the 11th District in New York City (1875–1879). (Courtesy of Library of Congress.)

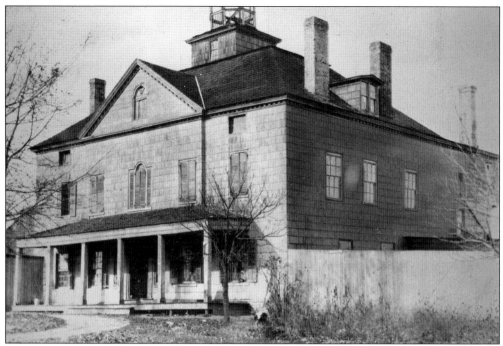

QUEENS COUNTY COURTHOUSE, GARDEN CITY PARK, C. 1890. In 1786, Queens County built this courthouse and jail on Jericho Turnpike in the geographical center of the county. A citizens' meeting here on January 22, 1898, set the stage for the secession of North Hempstead, Hempstead, and Oyster Bay from Queens County by proposing the creation of Nassau County. (Courtesy of Nassau County Division of Museum Services.)

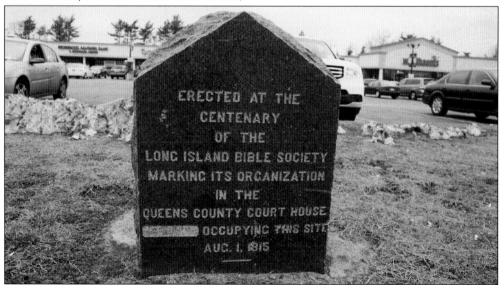

BIBLE SOCIETY MONUMENT. During the 1800s, the courthouse building also served as the meetinghouse for the Queens County Agricultural Society, the Queens County Medical Society, and the Long Island Bible Society. On March 28, 1910, the structure was completely destroyed by a fire. A historical marker was placed on the site, west of Herricks Road, in 1915 by the Long Island Bible Society to mark its founding location.

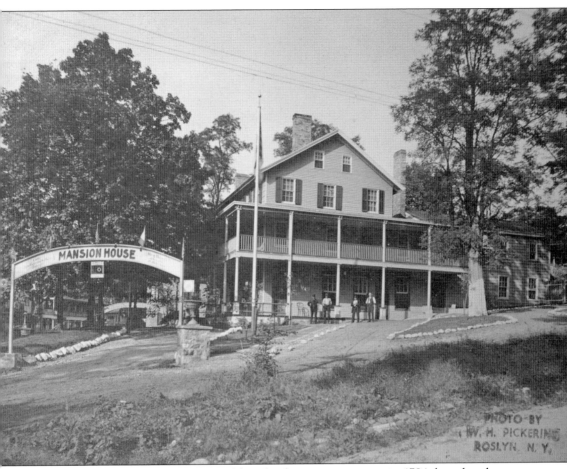

MANSION HOUSE, ROSLYN, C. 1906. After the first town meeting in 1784, board and town meetings were held at the homes of board members and rotated among inns, taverns, and hotels. Vital records were stored in the home of the town clerk. On March 4, 1905, the town approved $20,000 to build a town hall and vaults for the storage of records at the Mansion House. Built around 1810, the hotel was described by the *Brooklyn Daily Eagle* as a favorite country retreat for Brooklynites. The hotel was torn down after 1920. (Photograph by William Pickering; courtesy of Bryant Library.)

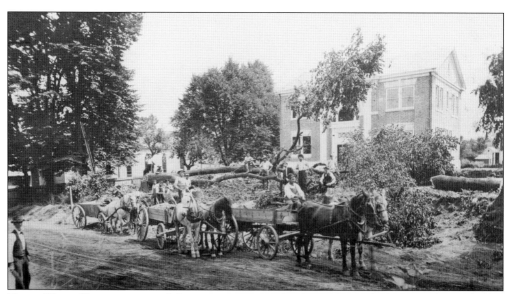

TOWN HALL CONSTRUCTION, MANHASSET, 1906. On May 23, 1905, the town board held a meeting to decide which village, among Mineola, Manhasset, and Roslyn, would have the new town hall. After five ballots, Roslyn and Manhasset were tied with three votes each. On the sixth ballot, Manhasset was declared the winner, with four votes to Roslyn's two. The Plandome Road site was chosen because of its central location and proximity to the railroad station across the street. Luther Birdsall of Roslyn was selected as the architect. Workers from Smull & Walsh of Port Washington are seen here clearing the land and building sidewalks. (Courtesy of Town of North Hempstead Archives.)

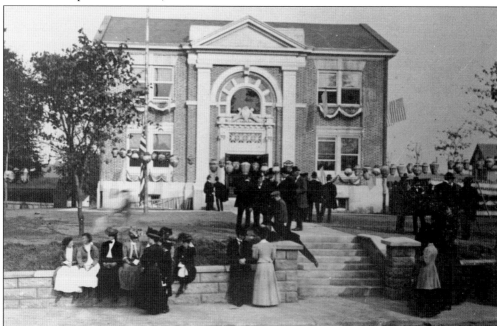

TOWN HALL DEDICATION, OCTOBER 16, 1907. The hall was presented to the residents at dedication ceremonies hosted by town supervisor Philip J. Christ. The building was enlarged in 1928. (Courtesy of Town of North Hempstead Archives.)

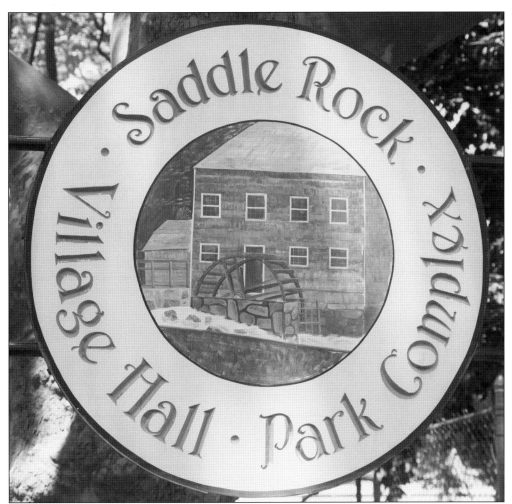

INCORPORATION OF VILLAGES. Until 1906, all the villages in the town were controlled by the government of the Town of North Hempstead. Over a 26-year period beginning with Mineola in 1906, a total of 30 villages within the town incorporated, with the right to establish local zoning ordinances and local taxes. Saddle Rock was the first of nine Great Neck villages to incorporate, in 1911. The last village to incorporate in North Hempstead was Westbury, on April 20, 1932. No new incorporated villages have been created since the 1936 County Charter denied zoning authority to future villages.

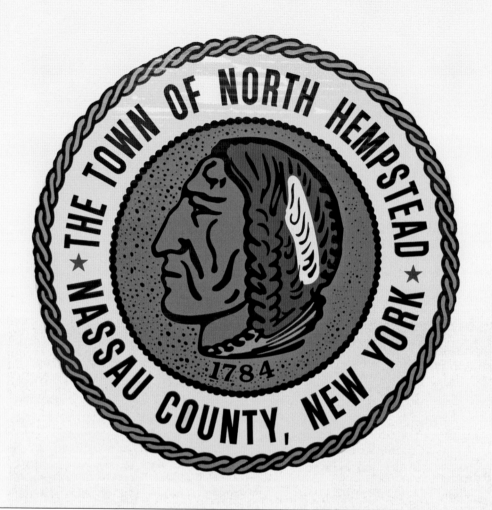

Town Logo. To honor the original inhabitants of the community, the town logo of North Hempstead was adopted on January 22, 1936. The illustration represents Tackapausha, the sachem of the Algonquians who lived in the area. The 1784 date refers to the year the town was approved by the New York Legislature. (Courtesy of Town of North Hempstead Archives.)

Two

PEOPLE AND PLACES

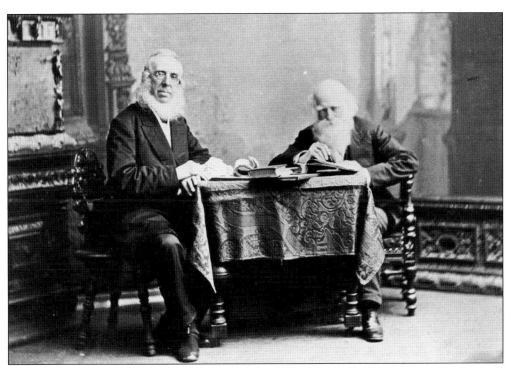

PETER COOPER VISITS WILLIAM CULLEN BRYANT, C. 1875. William Cullen Bryant (1794–1878) was an attorney, newspaper editor, poet, and civic leader. His home, Cedarmere, in Roslyn Harbor, was a magnet for writers and artists seeking Bryant's company. Bryant (right) met with Peter Cooper (1791–1883), founder of Cooper Union, to discuss Cooper's plan to run for president of the United States. (Courtesy of Nassau County Department of Museum Services.)

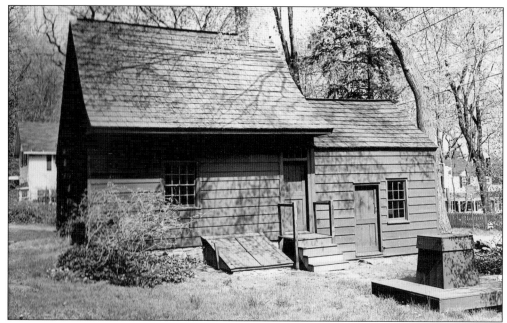

VAN NOSTRAND-STARKINS HOUSE, ROSLYN. Sections of this house, possibly the oldest on Long Island, date to 1680. In 1966, it was acquired by the Village of Roslyn. From 1973 to 1977, the house was restored to its 1800 appearance by the Roslyn Landmark Society, which currently leases the house from the village and operates it as a museum. (Courtesy of Roslyn Landmark Society.)

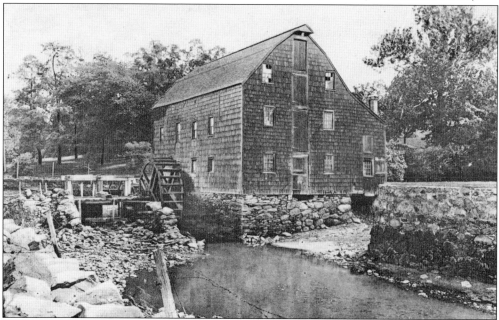

SADDLE ROCK GRISTMILL. Serving as a reminder of the historic importance of mills to the economy of Long Island, the Saddle Rock mill is one of the few remaining mills in the United States that operates by tidal flow rather than a continuous stream of water. In 1955, the mill became the property of Nassau County, which restored it to its 1830–1870 appearance. (Courtesy of Great Neck Library.)

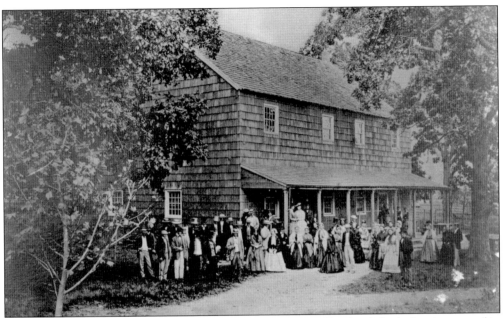

WESTBURY QUAKER MEETING, 1869. In 1658, Richard Stites and his family built their homestead in this area. It was the only farm until an English Quaker, Edmond Titus, and his son Samuel joined them. Other Quaker families who were also seeking a place to freely express their religious beliefs joined the Tituses and Willises. (Courtesy of Nassau County Division of Museum Services.)

MANHASSET QUAKER MEETING, C. 1924. Founded by the Religious Society of Friends in 1702, this building has been continuously used as a place of worship except when occupied by British and Hessian soldiers during the American Revolutionary War. The original meetinghouse was demolished in 1812 and rebuilt using the original timbers and benches. The huge oak tree is still standing. (Courtesy of Clarence Purchase Collection, SPLIA.)

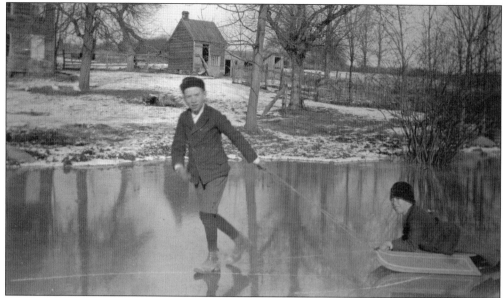

"Boys on Ice on Hewlett's Farm," Plandome, March 1907. The joy of a winter day was captured in this photograph, taken at a Hewlett farm. Generations of the Hewlett family lived throughout North Hempstead. A Hewlett farm was located in Flower Hill near what is now the North Hempstead Country Club, with the property extending to Hempstead Harbor. (Courtesy of The Witmer Photograph Collection, Cow Neck Peninsula Historical Society.)

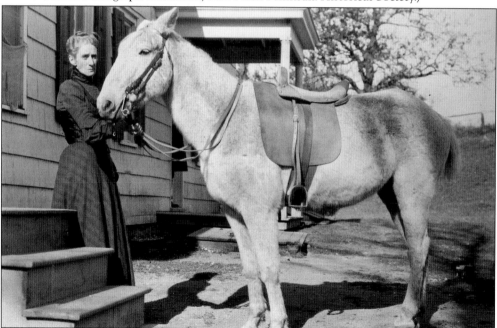

"Mrs. McKissock and Jack," Port Washington, October 1904. Draft horses like Jack were essential to life on North Hempstead at the turn of the century. They hauled carriages, plowed fields, and brought goods to New York City markets. Port Washington resident Mrs. McKissock enjoyed her horse more than having her photograph taken by John Witmer. (Courtesy of The Witmer Photograph Collection, Cow Neck Peninsula Historical Society.)

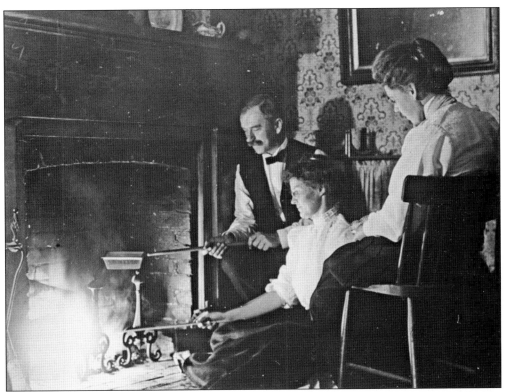

"FIREPLACE AT THE MCLEAN HOME, PORT WASHINGTON," OCTOBER 1906. Mary McLean (right) was the president of the Woman's Club of Port Washington from 1900 to 1913. McLean and her family were photographed by Witmer at the family home, which hosted Port Washington Library board meetings and fundraising events for the Methodist Church and library. (Courtesy of The Witmer Photograph Collection, Cow Neck Peninsula Historical Society.)

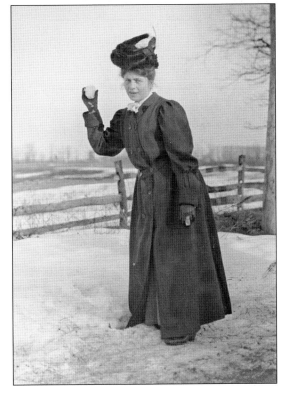

"MISS SPENCER THROWING A SNOWBALL," PORT WASHINGTON, MARCH 1907. In a simpler time, it was common practice to wear formal, "Sunday" clothes when entertaining, attending sporting events, and, apparently, having a snowball fight. John Witmer must have been impressed by the subject of this photograph. He later married Virginia Spencer. (Courtesy of The Witmer Photograph Collection, Cow Neck Peninsula Historical Society.)

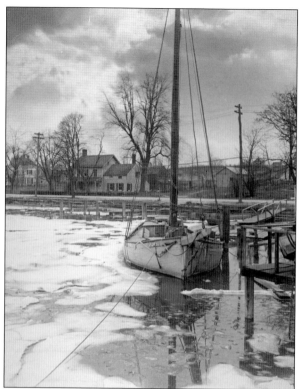

"OYSTER BOATS," MANHASSET BAY, PORT WASHINGTON, 1914. The winter tranquility of Manhasset Bay was captured by photographer Clarence Purchase. Boats on the bay were used for transportation, fishing, and recreation. The Baxter Homestead is in the background. (Courtesy of Clarence Purchase Collection, SPLIA.)

"MR. LANDIS, MISS LANDIS AND MISS THOMPSON ROCKWELL," PORT WASHINGTON, JUNE 1901. John Witmer's close friend in Port Washington was Henry K. Landis (1865–1955). Landis was an editor and photographer and founder of the Landis Valley Museum in Lancaster, Pennsylvania. His sister did not fall off the log. (Courtesy of The Witmer Photograph Collection, Cow Neck Peninsula Historical Society.)

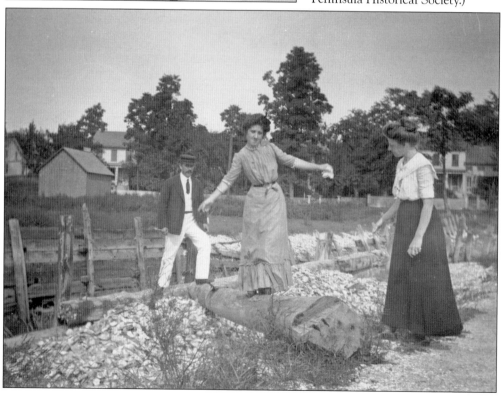

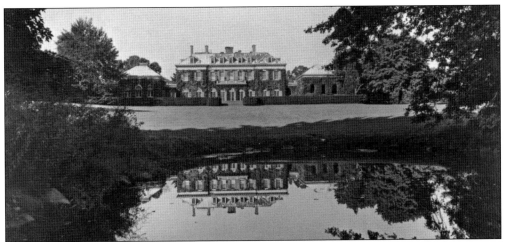

CLAYTON, HOME OF CHILDS FRICK, ROSLYN, 1938. The largely undeveloped inland property of William Cullen Bryant's 145-acre estate was purchased in 1900 by attorney, former US Congressman, and magazine editor Lloyd Stephens Bryce. Architect Odgen Codman Jr. was commissioned to design a Georgian mansion, which became known as Bryce House. The estate was purchased in 1919 by industrialist and art collector Henry Clay Frick (1849–1919). Frick, a cofounder of US Steel with Andrew Carnegie, gave the estate as a gift to his son Childs Frick. After renovating and expanding the mansion renamed Clayton, paleontologist Childs Frick (1883–1965) and his family lived there for almost 50 years. Following Childs Frick's death in 1965, the estate was purchased by Nassau County, which then converted it to a museum, now the Nassau County Museum of Art. (Above, courtesy of Nassau County Museum of Art; below, courtesy of The Metropolitan Museum of Art.)

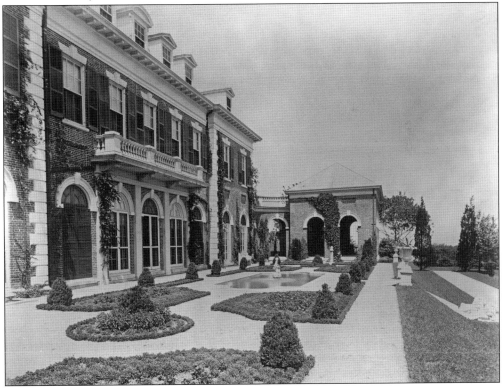

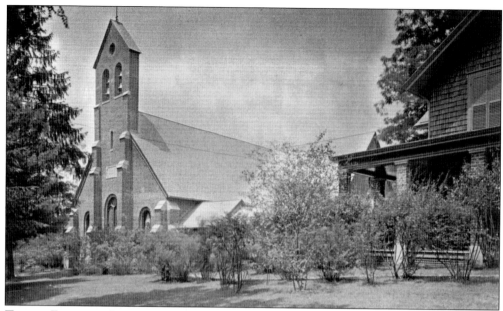

TRINITY EPISCOPAL CHURCH, ROSLYN, 1907. Designed by prominent architect Stanford White and donated by Roslyn socialite Katherine Duer Mackay (1880–1930), this church was built in 1906. This Norman-Early English Revival building was considered White's most ambitious church design. Several of the church's windows were made by Tiffany Studios. On March 22, 1907, the church was consecrated. In attendance were the Mackay family and many members of New York society. (Courtesy of Trinity Episcopal Church.)

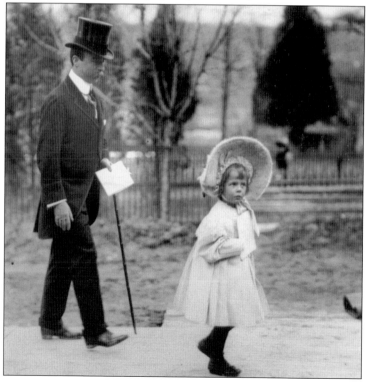

CLARENCE AND ELLIN MACKAY, TRINITY EPISCOPAL CHURCH. Clarence Mackay (1874–1938) and his daughter Ellin (1903–1988) arrive for the church's consecration on March 22, 1907. Against her father's wishes, at the age of 23, Ellin Mackay married composer Irving Berlin. After breaking off communications with his daughter for years, Clarence Mackay later reconciled with her and Berlin. (Courtesy of Trinity Episcopal Church.)

CONSERVATION POSTER, 1925. As
North Hempstead land began to be
extensively developed for housing
and business, the Association for
the Preservation of the Beauty
of North Hempstead (APBNH)
was organized in Plandome to
protect the trees of Long Island.

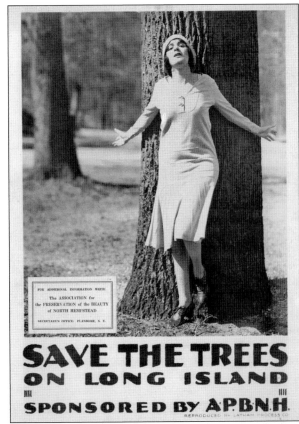

"SEARCHING FOR THE NEXT
MARY PICKFORD," AUGUST 23,
1919. The home of publisher
Eugene V. Brewster of Roslyn
hosted 25 aspiring actresses
who hoped to become the next
Mary Pickford. The women were
selected from 100,000 entries
in a contest held by a movie
magazine published by Brewster.
The women are being judged in
this photograph by Brewster, actor
Richard Barthelmess, Samuel
Lumieur, and Wilfred Lorth.

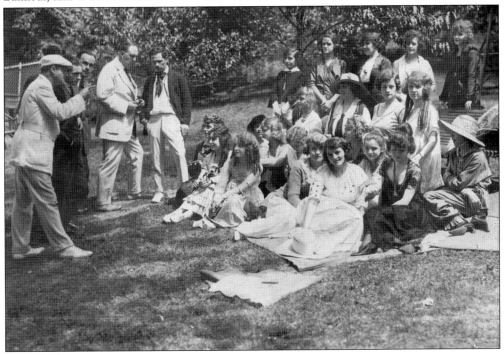

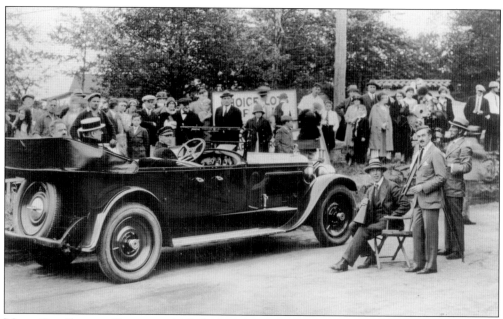

MOVIE SET, RUSSELL GARDENS, 1925. On May 23, 1925, the *Great Neck News* reported with pride that pioneering filmmaker D.W. Griffith (1875–1948) had chosen Russell Gardens, a new Great Neck development, for scenes for a silent film, *Sally and the Sawdust*, starring W.C. Fields and Carol Dempster. Griffith (sitting on chair) and Fields (in the car's back seat wearing a straw hat) are seen here on the Great Neck set. (Courtesy of Village of Russell Gardens.)

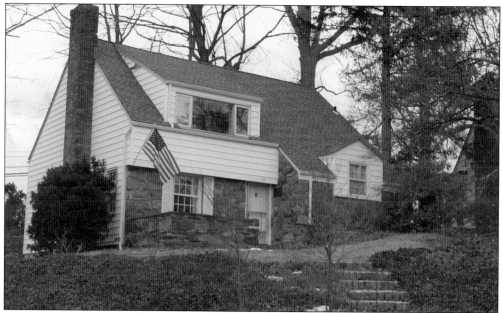

MIRACLE ON 34TH STREET HOUSE, PORT WASHINGTON. This is the memorable house that brought nine-year-old Natalie Wood's character to yell "Stop, Uncle Fred, Stop!" in the 1947 classic film *Miracle on 34th Street*. Except for the addition of the second-floor dormer, the house remains virtually unchanged since Kris Kringle's 1947 visit. The current owners keep a wooden cane in the living room.

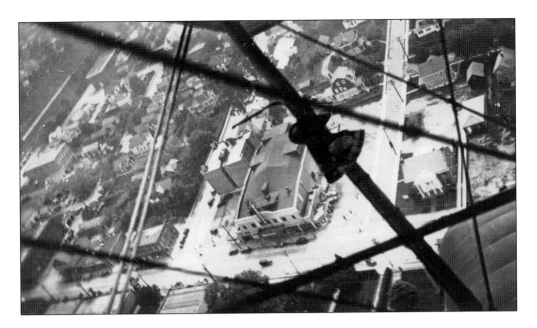

BEACON THEATER, POST WASHINGTON, 1932. Built in 1926, this huge theater on Main Street had stage shows and a large pipe organ. A candy store was attached to the theater, offering boxes of rock candy and its own chocolate. The above photograph was taken from a biplane, evident by the wing wires framing the building. In the early 1970s, the Beacon was one of the first North Hempstead theaters to be made into a triplex, with the balcony becoming one theater and two theaters created downstairs. It continues in operation today as a seven-plex cinema. (Above, courtesy of Port Washington Public Library; below, courtesy of Town of North Hempstead Archives.)

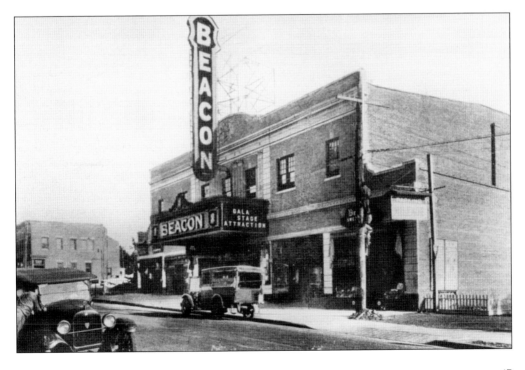

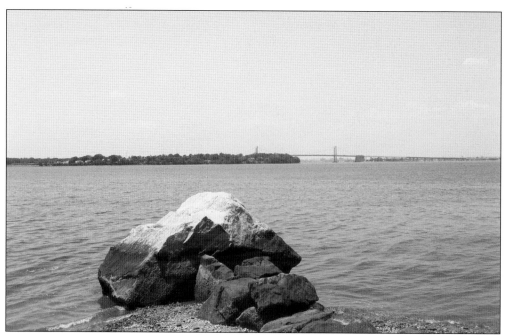

SADDLE ROCK, LITTLE NECK BAY. Located offshore in Little Neck Bay, this rock, a remnant of glaciers, resembles a high-pommel saddle. This unusual geological feature provided the name for the surrounding area, the village of Saddle Rock. The Throgs Neck Bridge can be seen in the background.

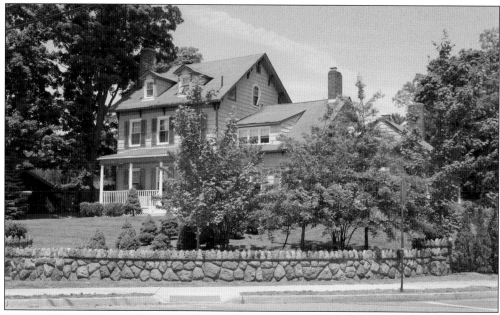

BAXTER HOUSE, BAXTER ESTATES. Overlooking Manhasset Bay, this property was purchased by Oliver Baxter on April 28, 1743, and remained in his family until the late 1800s. During the American Revolution, Hessian troops were quartered in the house. The Baxters were shipbuilders, whalers, sea captains, and blacksmiths, acquiring large property that would become the village of Baxter Estates. The house is currently a private residence.

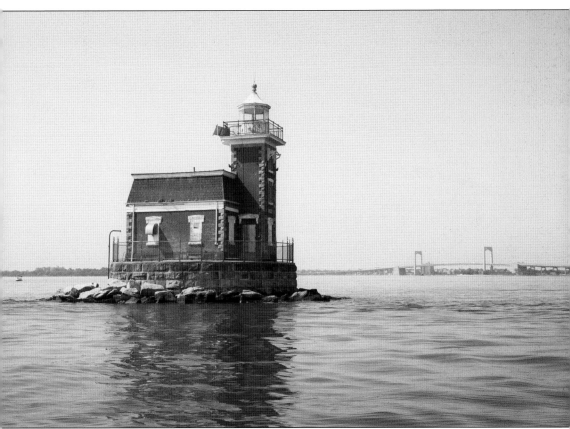

STEPPINGSTONES LIGHT, KINGS POINT. In the 1770s, the Long Island Sound became known as "Devil's Belt," due to the sudden storms and nor'easters and a native Siwanoy legend. Early maps labeled the sound as "Devil's Belt" and the reefs as the "Devil's Stepping Stones." The name "Devil's Stepping Stones" continued until 1877. In the 1860s, expanding shipping commerce on Long Island Sound resulted in the need for a lighthouse to define a clear channel. Construction of Stepping Stones Light was begun in late 1875 by A.D. Cook, Inc., a manufacturer of deep-well pumps and well supplies. The foundation of the tower was built directly over a large rock that just broke the surface at low tide. A total of 900 tons of boulders was barged to the site between 1875 and 1878. The light was first turned on for the night of March 1, 1877, with a fixed red light. The lighthouse was updated and modernized in 1944 and in October 1966. On September 15, 2005, the lighthouse was added to the National Register of Historic Places.

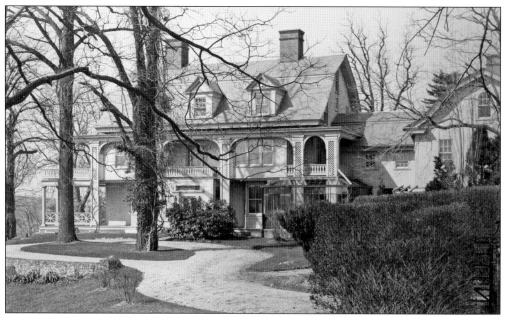

CEDARMERE, ROSLYN HARBOR. Poet, editor, and civic leader William Cullen Bryant purchased this estate in 1843 as a country retreat from New York City and changed its name to Cedarmere. Bryant spent eight to nine months of the year in the dwelling until his death in 1878. On November 15, 1902, fire destroyed the upper levels of the house. Most of the valuable books and furnishings were saved. The above photograph shows Cedarmere in March 1905 after it was restored by Bryant's son-in-law Harold Godwin. The property remained in the Bryant family until the death of Bryant's granddaughter Elizabeth Love Godwin in 1975. (Courtesy of The Witmer Photograph Collection, Cow Neck Peninsula Historical Society.)

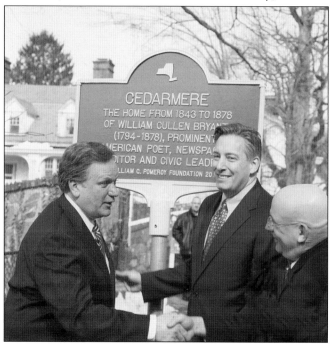

INSTALLATION OF HISTORICAL MARKER AT CEDARMERE, ROSLYN HARBOR, FEBRUARY 13, 2013. The seven-acre estate was bequeathed in 1975 to Nassau County by Elizabeth Love Godwin as a memorial to her grandfather, William Cullen Bryant. A museum was opened in 1994 by Nassau County in honor of the 200th anniversary of William Cullen Bryant's birth. Upon receiving a Pomeroy Foundation grant, a historic marker was installed at Cedarmere in 2013. The installation was celebrated by county executive Edward Mangano (left), town supervisor Jon Kaiman (center), and town historian Howard Kroplick (right).

Three

WORK

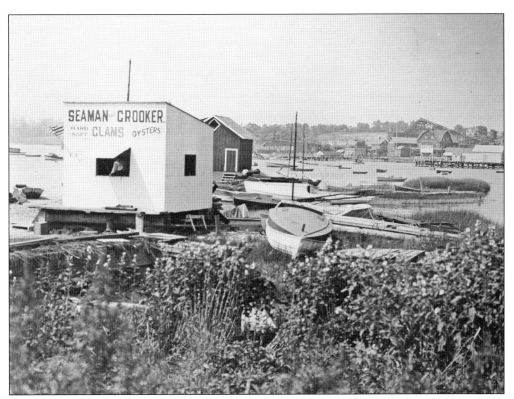

OYSTER HOUSE, PORT WASHINGTON, JULY 1911. For over 200 years, the harbors and bays of North Hempstead and the Long Island Sound supported a thriving maritime economy for fishermen, boatbuilders, and sailmakers. In 1855, businessmen invested in planting oysters in Cow Bay (Manhasset Bay), leading to the development of commercial oyster farming in North Hempstead. (Courtesy of The Witmer Photograph Collection, Cow Neck Peninsula Historical Society.)

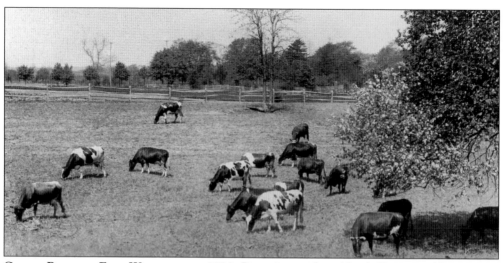

CATTLE PASTURE, EAST WILLISTON, C. 1890. Pasturing cattle in North Hempstead began soon after the initial settlement in 1643. The settlers established farms on the Hempstead Plains and pastured their cattle on the hilly Cow Neck peninsula, which had an abundant supply of water. On May 2, 1654, the board required that "Ye Inhabitants" with rights in "ye neck" shall fence in the property. (Courtesy of Village of East Williston.)

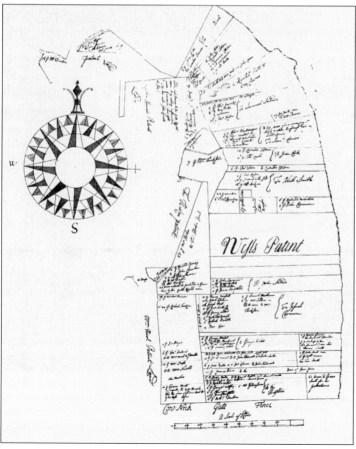

COW NECK MAP, 1709. By 1695, the town decided that the rich grazing land of Cow Neck (present-day Manhasset, Flower Hill, Port Washington, and Sands Point) could no longer be treated as a huge common pasture. A total of three miles was parceled out to the 61 people who had built fences ("Gates") from Hempstead Harbor to Manhasset Bay. (Courtesy of Town of North Hempstead Archives.)

KOLB HOMESTEAD, NEW HYDE PARK, 1921. The rich, spring-fed soil and meadows of North Hempstead and its ponds helped make farming the primary occupation through the 1800s. Farmers raised vegetables and wheat; kept chickens, hens, and cows; and bred horses for transportation. Many farmers raised sheep for wool. Oysters, clams, and fish provided residents with a varied diet. (Courtesy of Clarence Purchase Collection, SPLIA.)

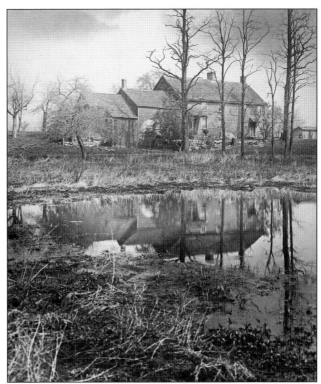

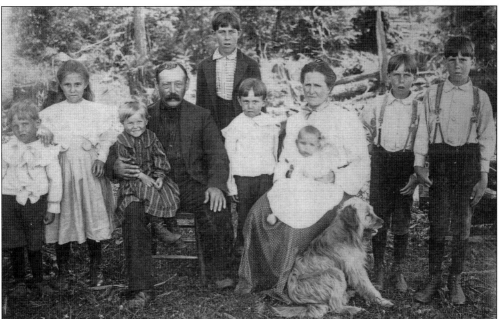

DIETZ FAMILY, PLANDOME HEIGHTS, c. 1905. As their farms flourished, farmers turned from subsistence farming to selling products for New York City markets. Improvements in transportation, from sloops on the harbors and bays to the Long Island Rail Road to improved roads, made farming even more profitable. Joe Dietz, his wife, and eight children had a typical North Hempstead farm, growing produce and raising horses. (Courtesy of Manhasset Public Library.)

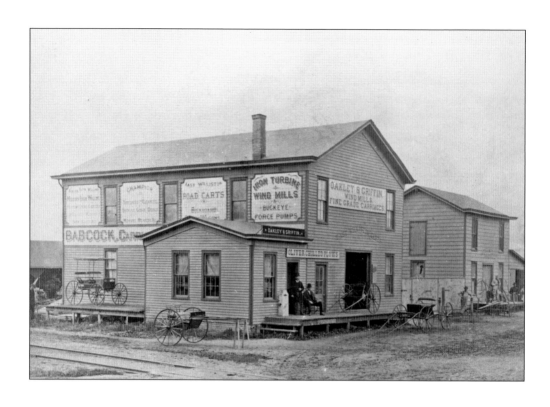

OAKLEY & GRIFFIN CART COMPANY, EAST WILLISTON. Before electricity, much of the power needed on farms was supplied by the wind. To meet this demand, Henry M. Willis established a windmill and carriage factory west of the railroad and south of East Williston Road prior to 1880. The factory is seen above in 1890. The company's most successful product was the two-horse road cart (below). The cart, designed and patented by Willis, was popular due to its stable, smooth ride. In 1889, Foster L. Oakley and William H. Griffin purchased the business and renamed it Oakley & Griffin. (Both, courtesy of Town of North Hempstead Archives.)

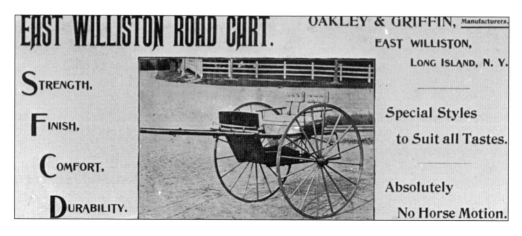

ROBESON-WILLIAMS GRISTMILL, ROSLYN, 1909. Before 1741, Jeremiah Williams built the mill shown here, which survives today. It is one of the few Dutch Colonial commercial frame buildings remaining in the United States. From 1919 to the 1960s, it was used as a teahouse. It was acquired by Nassau County in 1975. Restoration is still ongoing to stabilize the structure and preserve the building. (Courtesy of Bryant Library.)

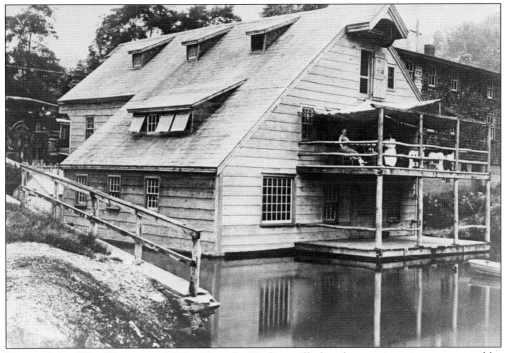

ROSLYN MILL TEA HOUSE, C. 1919. After the Roslyn mill closed operations, it was restored by a group of trustees, including Harold Godwin, the grandson of William Cullen Bryant. To help generate funds for the building, the Roslyn Mill Tea House operated from 1919 until 1975. Alice C. Titus (1893–1980) was the proprietor of the teahouse from 1919 until her retirement in 1951. (Courtesy of Nassau County Department of Museum Services.)

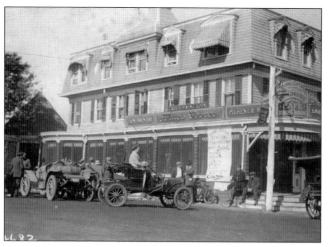

KRUG'S CORNER HOTEL, MINEOLA, OCTOBER 1910. As the town's population grew and new businesses were created, there was a demand for inns, hotels, restaurants, and taverns. Krug's, located on the northwest corner of Jericho Turnpike and Willis Avenue, was a favorite inn of tourists and residents, especially during the Vanderbilt Cup Races from 1904 to 1910. Here, Jane Molitor Krug, the wife of proprietor Frank Krug, sits in her car.

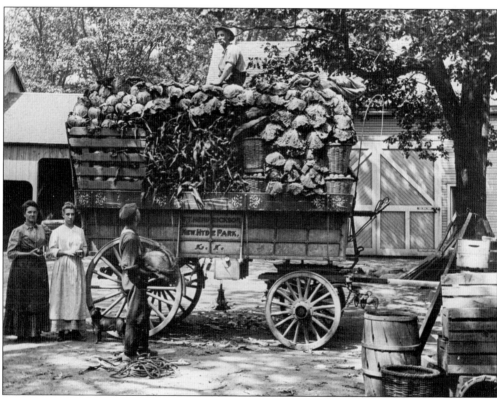

FARMER'S WAGON, 1905. Farmer Wilbur Hendrickson of New Hyde Park proudly displayed his wagon of cabbages, likely headed to a New York City market. In 1871, Hendrickson's neighbors wished to establish a post office with the village name of Hyde Park. The request was accepted only after it was renamed New Hyde Park to avoid confusion with the Dutchess County village, the future birthplace of Pres. Franklin D. Roosevelt. (Courtesy of Nassau County Division of Museum Services.)

"Fish Peddler's Cart," Manhasset, 1915. In the early 1900s, produce, meat, and fish were often delivered to North Hempstead residents by horse-drawn carriages. Most of the roads remained unpaved and were difficult to traverse in poor weather. A fish logo is visible on the side of the cart. (Courtesy of Clarence Purchase Collection, SPLIA.)

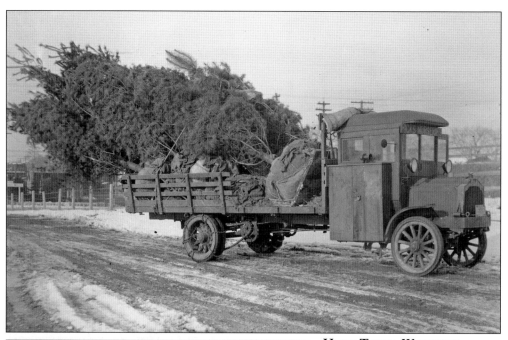

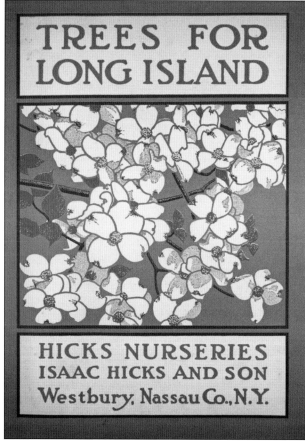

TREES FOR LONG ISLAND

HICKS NURSERIES
ISAAC HICKS AND SON
Westbury, Nassau Co., N.Y.

HICKS TRUCK, WESTBURY, 1922. The Hicks family started farming on Long Island as early as the late 1600s. In 1853, Isaac Hicks founded Hicks Nursery, Inc., which soon did a booming business supplying trees, plants, and shrubs for country homes and estates. (Courtesy of Hicks Nursery.)

HICKS NURSERIES BROCHURE, c. 1925. Around 1900, Isaac's son Edward invented and patented equipment for moving large trees desired by the estate owners. Full-grown trees were extracted from the nursery and taken to estates throughout Long Island and the New York area. The sixth generation of the Hicks family is still actively involved in the management of the nursery. (Courtesy of Al Velocci.)

Louis Oshansky, Floral Park, c. 1920. This toy and cigar store was built by Jacob Oshansky in 1917. The flags and decorations were celebrating the annual Firemen's Day, when businesses and private residences competed for prizes. (Courtesy of Village of Floral Park.)

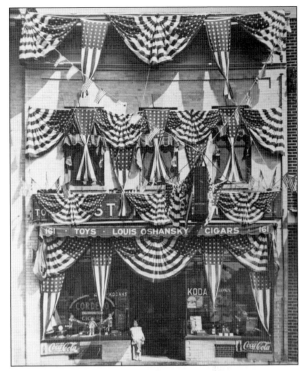

The Great Atlantic & Pacific Tea Company, Mineola, c. 1920. The forerunner of A&P began in 1859, then established a chain of retail and coffee stores throughout New York City. By 1915, it became the country's first grocery chain, with 1,600 stores. This Mineola store featured A&P's Bokar brand of dark-roasted coffee for 43¢ a pound and unfiltered cigarettes for $1.15 per carton. (Courtesy of Queens Borough Public Library, Joseph Burt Sr. Collection.)

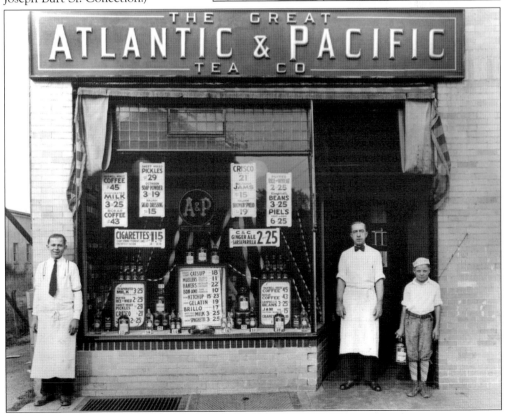

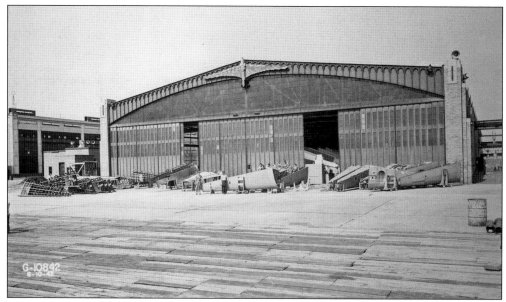

GRUMMAN PLANT NO. 15, MANORHAVEN, 1943. In 1929, the American Aeronautical Corporation built a major seaplane base on a 16-acre property on Manhasset Isle. In 1943, Grumman Aircraft Engineering Corporation took over the terminal to build parts for the Navy's Avenger torpedo bombers and Hellcat fighter planes. Operating 24 hours a day, Plant No. 15 employed more than 4,000 workers to assemble wing panels, cowlings, and turrets. (Courtesy of Cradle of Aviation.)

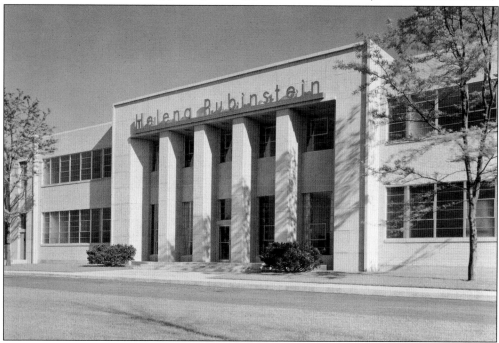

HELENA RUBINSTEIN PLANT, EAST HILLS, 1958. Over two million makeup and mascara products were produced and sold from this 315,000-square-foot Helena Rubinstein plant, which opened in 1953. The plant was sold in 1980 to the Pall Corporation, becoming their corporate headquarters until 2009. The building is currently being developed as a multiuse office complex.

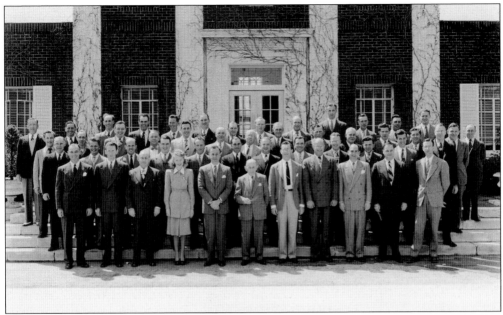

LEVITT & SONS, MANHASSET, 1947. Levitt & Sons, the largest private builder of houses following World War II, had its headquarters on Northern Boulevard in Manhasset. Abraham Levitt (1880–1962), the company's founder, is seen here, sixth from the left in the first row. Among his staff of 49 employees are the "Sons," William and Alfred Levitt. (Courtesy of Collection of the New-York Historical Society.)

NORTH STRATHMORE DEVELOPMENT, MANHASSET. In 1933, Levitt & Sons built 200 homes in a development called North Strathmore on the 50-acre former Onderdonk property. The houses sold for between $9,100 and $18,000 (equal to $163,000 to $323,000 today). The Onderdonk House served as the Levitts' sales office and was transferred to the residents' Strathmore Association after all the homes were sold. Levitt would build another 1,200 homes in Manhasset, Great Neck, and Westchester before developing 17,000 houses in Levittown.

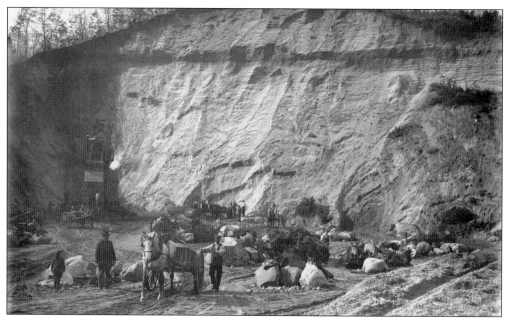

HEMPSTEAD HARBOR SANDPITS, 1897. Between 1865 and 1989, more than 200 million tons of sand from Hempstead Harbor mines were shipped from Port Washington to New York City to make concrete for skyscrapers, subway tunnels, foundations, and sidewalks. An estimated 90 percent of all the concrete used to build New York City came from these sandpits. (Courtesy of Suffolk County Historical Society.)

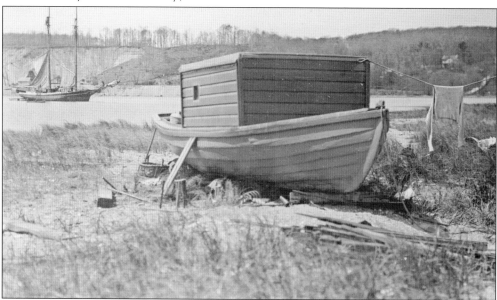

HOUSEBOAT ON BAR BEACH, MAY 1907. The nine acres of land jutting from the Port Washington sandpits crossing Hempstead Harbor was originally called Barrow Beach and then was shortened to Bar Beach. This scenic location was the home for bungalows and houseboats. A schooner and a sandpit sea cliff can be seen in the background. Bar Beach is now part of the 60-acre North Hempstead Beach Park for town residents. (Courtesy of The Witmer Photograph Collection, Cow Neck Peninsula Historical Society.)

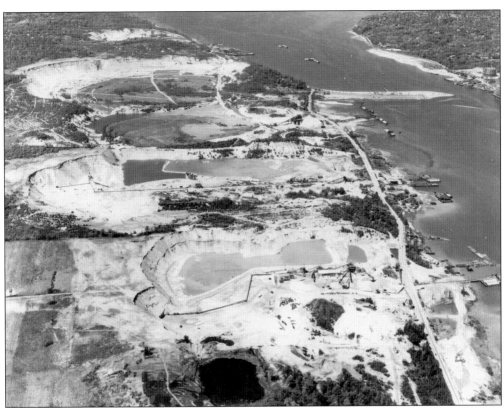

SANDPITS, HEMPSTEAD HARBOR, C. 1925. This aerial photograph shows the Port Washington sandpits and accompanying docks and barges. Over 50 barges a day left Hempstead Harbor and Manhasset Bay with "Cow Bay" sand and gravel. Summer bungalows can be seen in the center of the photograph, on the white Bar Beach. The sandpits on the left have been transformed into a commercial building park and the Town of North Hempstead's Harbor Links Golf Course. (Courtesy of Town of North Hempstead Archives.)

SANDMINERS MONUMENT PARK, PORT WASHINGTON. The last sand-mining company ceased operations in 1989. In recognition of the industry's impact on the town and the workers' contributions in building New York City, a monument was unveiled on September 25, 2010. It is part of a town park located on a former mining site on West Shore Road, adjacent to Harbor Links Golf Course.

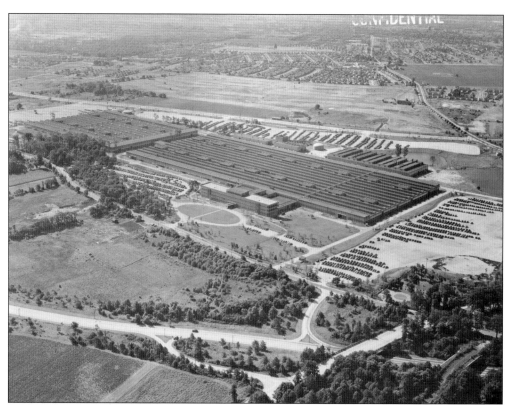

SPERRY GYROSCOPE PLANT, SEPTEMBER 27, 1952. This is the 1.4-million-square-foot plant for Sperry, manufacturer of a variety of military, maritime, aviation, and navigation products. During World War II, the plant, in Lake Success, had 22,000 employees. Sperry and the plant were acquired by Loral Corp., then Unisys, and later by Lockheed Martin before being closed in 1998. The plant has been transformed into an office complex. (Courtesy of UCLA Department of Geography, Benjamin and Gladys Thomas Air Photo Archives, the Fairchild Collection.)

TEMPORARY UNITED NATIONS, JUNE 30, 1951. Sections of the Sperry building served as the temporary headquarters for the United Nations from 1946 to 1952. On November 29, 1947, the United Nations voted in this building in favor of establishing a Jewish state in Israel.

Four

TRAVEL

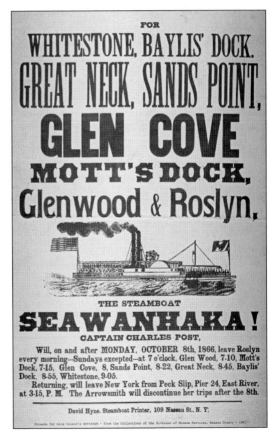

FOR

WHITESTONE, BAYLIS' DOCK.
GREAT NECK, SANDS POINT,
GLEN COVE
MOTT'S DOCK,
Glenwood & Roslyn,

THE STEAMBOAT
SEAWANHAKA !
CAPTAIN CHARLES POST,

Will, on and after MONDAY, OCTOBER 8th, 1866, leave Roslyn every morning—Sundays excepted—at 7 o'clock, Glen Wood, 7.10, Mott's Dock, 7-15, Glen Cove, 8, Sands Point, 8-22, Great Neck, 8-45, Baylis' Dock, 8-55, Whitestone, 9-05.

Returning, will leave New York from Peck Slip, Pier 24, East River, at 3-15, P. M. The Arrowsmith will discontinue her trips after the 8th.

David Hyne. Steamboat Printer, 109 Nassau St., N. Y.

Friends for Long Island's heritage - from the Collections of the Division of Museum Services, Nassau County - 1902

STEAMBOAT *SEAWANHAKA*, C. 1870. As demand increased for bringing goods and people to New York City, steamboats began to travel to North Hempstead harbors. The most famous of these steamships was the 612-ton, 230-foot-long side paddle-wheeled *Seawanhaka*, built in 1866. On June 28, 1880, the steamer, carrying 300 Long Island–bound commuters, caught fire in the East River. The tragedy claimed 61 lives. (Courtesy of Ian Zwerling.)

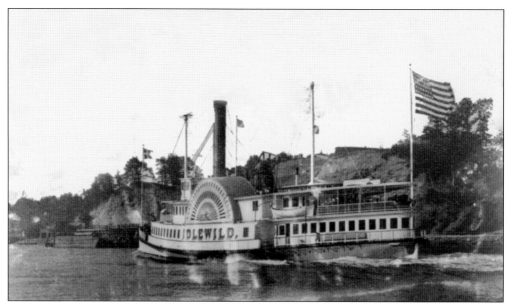

STEAMSHIP IDLEWILD, PORT WASHINGTON, C. 1885. After the *Sewanhanka* was lost, its place was taken by the side-wheeler steamship *Idlewild*. From 1879 to 1886, the ship brought passengers, freight, and livestock between Glenwood Landing and Peck's Slip, near the present-day South Street Seaport in lower Manhattan. The captain of the *Idlewild* was Stephen Mott, whose grandfather, Jackson Mott, had built the Glenwood Landing dock in 1805. (Courtesy of Port Washington Public Library.)

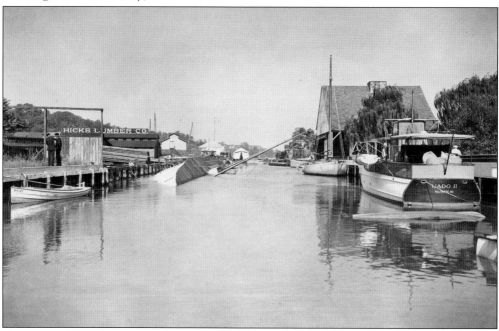

HEMPSTEAD HARBOR CREEK, ROSLYN, SEPTEMBER 21, 1938. One of the greatest weather disasters to strike North Hempstead was the Category 3 hurricane called the "Long Island Express." The result of the 1938 hurricane is seen here, when the village of Roslyn had a navigable harbor. (Courtesy of John Santos.)

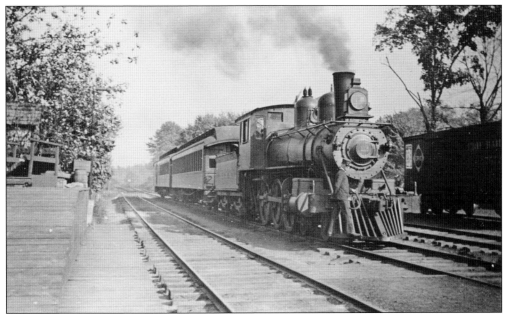

LONG ISLAND RAIL ROAD TRAIN, GREAT NECK, 1901. North Shore Railroad extended its Flushing line to Great Neck in 1866. In the mid-1870s, the branch became part of the Long Island Rail Road, which built its first Great Neck station in 1883. As a result of the station, businesses grew in the southern section of the village. (Courtesy of The Witmer Photograph Collection, Cow Neck Peninsula Historical Society.)

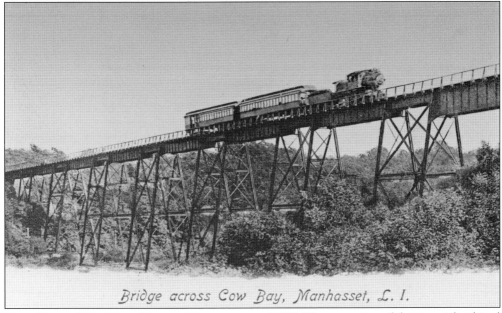

Bridge across Cow Bay, Manhasset, L. I.

LONG ISLAND RAIL ROAD BRIDGE, MANHASSET, C. 1900. The extension of the Long Island Rail Road east to Manhasset and Port Washington required that a trestle bridge be built over the marshlands of Manhasset Bay. The 81-foot-high, 678-foot-long bridge was built by the Carnegie Steel Company for $60,000 ($1.6 million today). The first train crossed it on June 23, 1898. (Courtesy of Manhasset Library.)

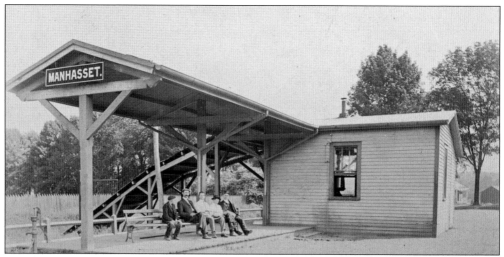

MANHASSET STATION, C. 1899. This modest wooden frame building, the first Manhasset depot station, is seen shortly after its opening in 1899. The railroad's impact was dramatic, as the primary business district of Manhasset eventually relocated from the "Valley" near the bay to the "Hill" near the train station. The depot station was replaced by a larger station on March 23, 1925, which is still operating today. (Courtesy of Manhasset Library.)

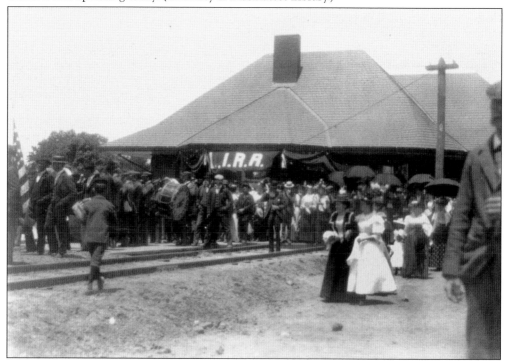

DEDICATION OF PORT WASHINGTON STATION, JUNE 23, 1898. The arrival of the first train in Port Washington was the major event of 1898. When the big day came, thousands enjoyed the biggest celebration in the village's history. As a result of being connected with the city, Port Washington boomed. When the branch electrified in 1913, the village's population more than doubled, to 5,500. On the 25th anniversary of the opening, in 1923, the population had doubled again to 11,000. (Courtesy of Town of North Hempstead Archives.)

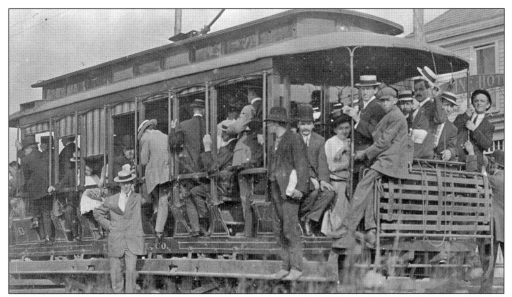

TROLLEY ON JERICHO TURNPIKE, FLORAL PARK, C. 1912. The hills, valleys, and harbors of North Hempstead made it impractical for railroads to connect each port and major population center. At the turn of the 20th century, automobiles were expensive, and roads were unpaved. As a result, electric trolley systems were built to connect North Hempstead villages with the relatively distant railroad stations. (Courtesy of Village of Floral Park.)

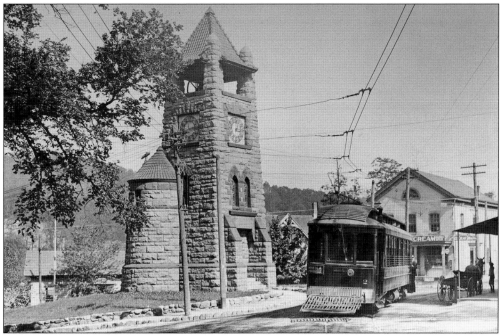

TROLLEY AT ROSLYN CLOCK TOWER, 1910. Beginning in June 1907, the New York & North Shore Traction Company established trolley service between Flushing and the major North Hempstead communities of Great Neck, Port Washington, Roslyn, Mineola, and Westbury before heading on to Hicksville. The trolley service ended in 1920, when it was largely replaced by commercial buses. (Courtesy of Bryant Library.)

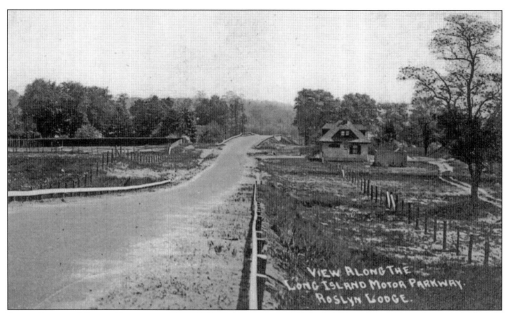

LONG ISLAND MOTOR PARKWAY, EAST WILLISTON, 1928. From 1908 to 1926, William K. Vanderbilt Jr. and his business associates built the first road specifically for the automobile. The 44 miles of concrete road included 14 miles in North Hempstead, helping to transform rural farmland into sprawling suburbs. This section is the motor parkway between the bridge over the Oyster Bay Long Island Rail Road line and the bridge over Roslyn Road. The Roslyn Lodge for collecting tolls can be seen on the right.

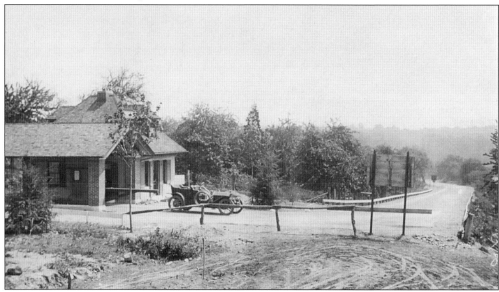

GREAT NECK LODGE, LAKE SUCCESS, 1910. In 1910, the Long Island Motor Parkway terminated at Lakeville Road in Lake Success. The Great Neck Lodge, seen on the left, was one of 20 toll collection structures that would be built for the parkway. Before closing in 1938, the motor parkway stretched from Fresh Meadows, Queens, to Lake Ronkonkoma in Suffolk County. Features pioneered by the parkway include the use of reinforced concrete, bridges to eliminate grade crossings, banked curves, guardrails, and landscaping. (Courtesy of Virginia Murray.)

NORTHERN STATE PARKWAY
CORNERSTONE CEREMONY, JULY
26, 1931. Gov. Franklin D.
Roosevelt (center) participated in
the gateway cornerstone ceremony
for the Northern State Parkway
at the construction site on the
Queens/Nassau border. Robert
Moses, chairman of the Long
Island State Parkway Commission
(just right of FDR), outlined plans
for the Grand Central Parkway.
(Courtesy of New York State
Parks, Bureau of Historic Sites.)

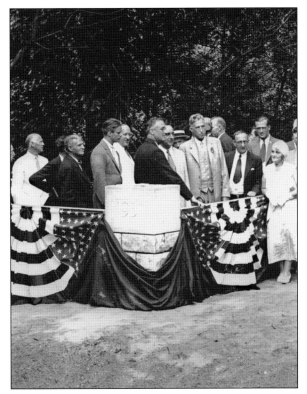

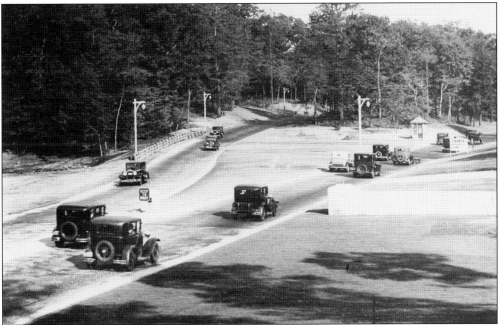

NORTHERN STATE PARKWAY GATEWAY, OCTOBER 8, 1933. A little more than two years after the
cornerstone ceremony, the "gateway" to the Northern State Parkway and North Hempstead was
opened for business. The gateway was located on the Queens/Nassau border. (Courtesy of New
York State Parks, Bureau of Historic Sites.)

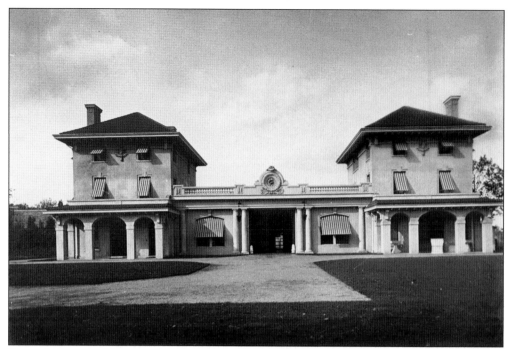

GRAVE'S GARAGE, MINEOLA, 1910. One of the largest and most elegant early garages was built by Robert Graves, the owner of Mercedes racers that were entered in the 1906 and 1908 Vanderbilt Cup Races. From 1922 to 2010, this location was the home to Corpus Christi School. (Photograph by Otto Korten; courtesy of Nassau County Department of Museum Services.)

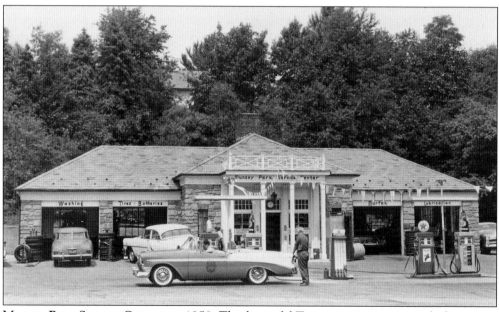

MUNSEY PARK SERVICE CENTER, C. 1958. This beautiful Texaco station was typical of many gas stations built in the 1950s in North Hempstead. A 1956 Chevrolet Bel Air can be seen at the gas pump. Sadly, this station was demolished for a small shopping center in the 1990s.

Roslyn Viaduct, 1947. In order to ease traffic in the village of Roslyn, a half-mile bypass and viaduct was constructed over Hempstead Harbor. The viaduct connected Northern Boulevard, the only major east-west road in North Hempstead except for the Long Island Expressway. Note the concrete piers in place to hold up future steel sections of the bridge.

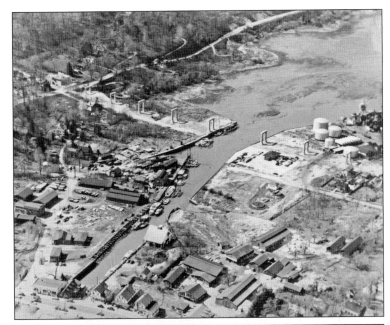

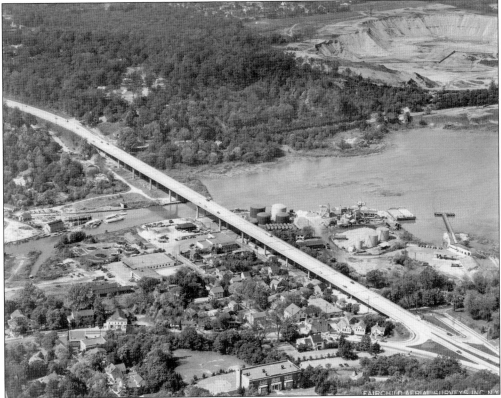

Roslyn Viaduct, c. 1957. The viaduct is seen here after its completion. From 2005 to 2011, this viaduct was replaced by a state-of-the-art bridge constructed of precast segments that extended up to 21 feet. To honor William Cullen Bryant, who lived nearby in Roslyn Harbor, the viaduct was renamed the Bryant Viaduct in 2012 by New York State.

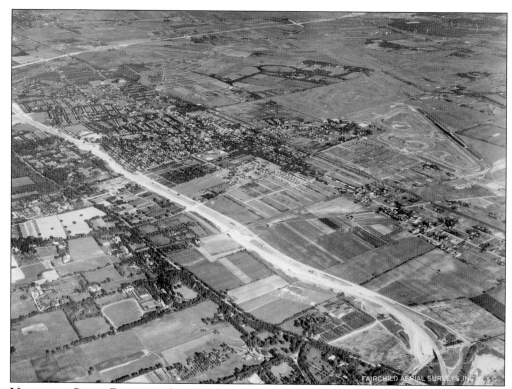

NORTHERN STATE PARKWAY, OLD WESTBURY, AND WESTBURY, C. 1939. Aerial surveys were used to show progress of the development of the major roads on Long Island. Here, the Northern State Parkway is shown being extended toward Eastern Long Island. Roosevelt Raceway, with its 60,000-person capacity grandstands, can be seen on the right. This raceway was used for the 1936 and 1937 Vanderbilt Cup Races, then midget races, and then harness horse racing before closing and moving to a location farther south.

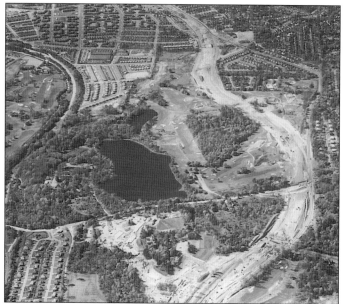

LONG ISLAND EXPRESSWAY, LAKE SUCCESS, AND NEW HYDE PARK, OCTOBER 1956. Called by local residents the "world's longest parking lot," the Long Island Expressway is shown being built north of the Sperry plant. Constructed in stages for over 30 years, the expressway (also known as Interstate 495) is currently 71 miles long, spanning from the Queens-Midtown Tunnel to Riverhead in Suffolk County. The Deepdale Country Club can be seen to the right, north of the construction.

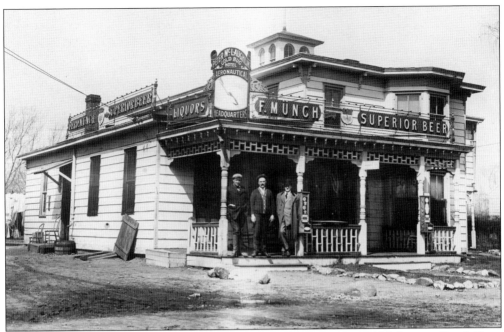

GOLD BUG HOTEL, MINEOLA, C. 1910. Located on the north side of Old Country Road, Peter McLaughlin's inn became the center of Long Island aviation history when the "father of the American aircraft industry," Glenn Curtiss, made it his headquarters. In the early 1900s, Curtiss tested his pioneering airplanes in a nearby Washington Avenue field adjoining the Mineola Fairgrounds. His famous *Golden Flyer* airplane was kept in a tent adjacent to the inn. In 1909, he flew this plane a distance of 24.7 miles to establish a new distance record. (Both, courtesy of Cradle of Aviation.)

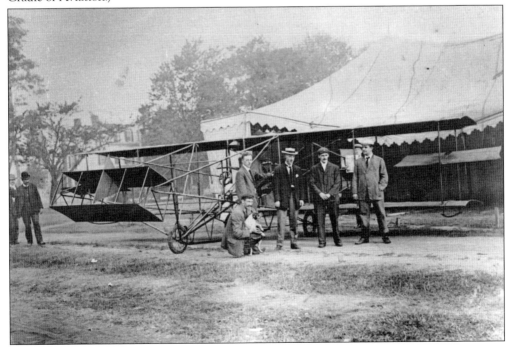

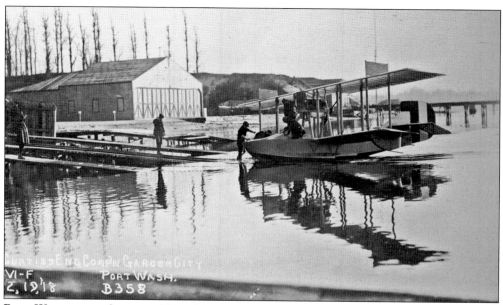

PORT WASHINGTON SEAPLANE BASE, MANHASSET BAY, 1918. The large protected body of water and the area's proximity to New York City and Long Island plane manufacturers made Manhasset Bay a mecca for seaplanes through the 1930s. Here, a Curtiss MF Flying Boat built in Garden City is being tested in front of a Port Washington hangar. The MF (Modernized F-boat) was powered by a 100-horsepower engine and incorporated sponsons (short wings under the fuselage) for greater stability. (Courtesy of Cradle of Aviation.)

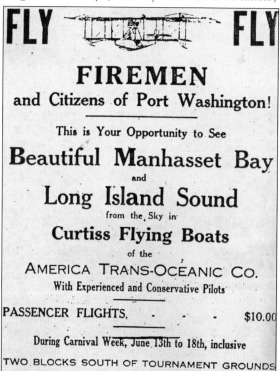

CURTISS FLYING BOAT POSTER, MANHASSET BAY, JUNE 10, 1921. Rodman Wanamaker (1863–1928), the son of the department store magnate John Wanamaker, established the America Trans-Oceanic Company, a seaplane flying school based in Port Washington. In 1921, the school offered sightseeing flights over Manhasset Bay and the Long Island Sound. Prior to World War I, Wanamaker was a pioneer in encouraging the development of a flying boat capable of crossing the Atlantic. (Courtesy of Cradle of Aviation.)

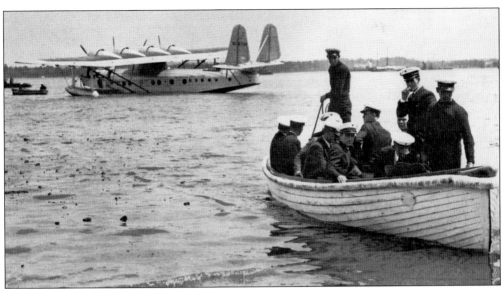

FIRST COMMERCIAL SURVEY FLIGHTS ACROSS THE NORTH ATLANTIC, 1937. The first commercial survey flights across the Atlantic, made jointly by Pan American Airways and Imperial Airways, evaluated the feasibility of commercial transatlantic passenger flights. As seen above, piloted by Capt. Harold E. Gray, the Pan American Sikorsky S-42B Clipper flying boat departed from Port Washington and arrived at Foynes, Ireland. Below, piloted by Capt. Arthur S. Wilcockson, the Imperial Airways Short "G" class flying boat "Caledonia" arrived at Port Washington on July 9, 1937, from Foynes. A monument on the town dock in Port Washington commemorates the event: "Thus was pioneered the beginning of a new era in communications between the peoples of the world." (Above, courtesy of Cradle of Aviation; below, courtesy of R.N. Smith Collection.)

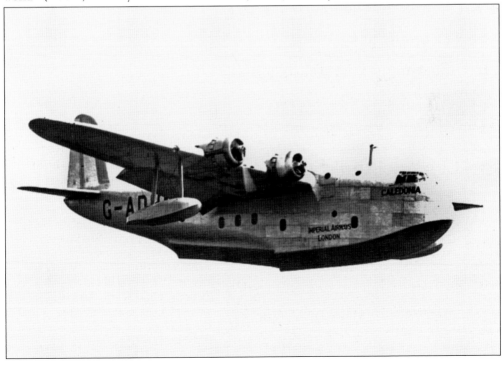

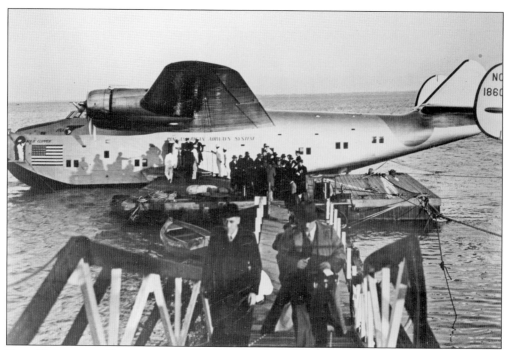

First Commercial Transatlantic Flights, 1939. The first commercial transatlantic flight was made by the Pan Am Boeing 314 "Yankee Clipper" on May 20–21, 1939, from Manhasset Bay, Port Washington, to Marseilles, France. Carrying only mail, the flight took 26 hours, 54 minutes, including a refueling in the Azores. On June 28, 1939, the first commercial passenger flight was made by the Pan Am Boeing 314 "Dixie Clipper," carrying 22 passengers from Port Washington for a one-way fee of $375, equal to $6,285 today. In the above photograph, the passengers can be seen arriving on in Lisbon, Portugal, after a refueling stop in the Azores. (Both, courtesy of Cradle of Aviation.)

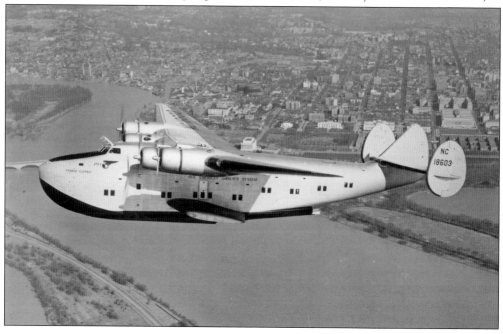

Five

SPORTS

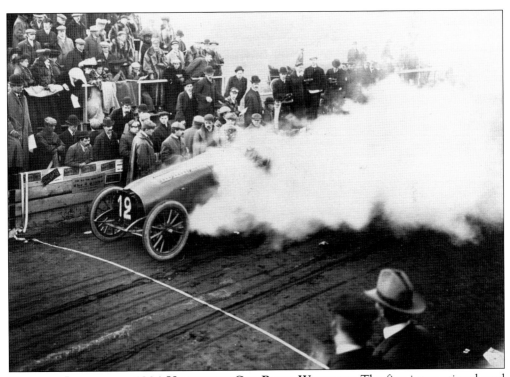

STARTING LINE OF THE 1904 VANDERBILT CUP RACE, WESTBURY. The first international road races in the United States were the Vanderbilt Cup Races held on Long Island from 1904 to 1910. These races were the most prestigious sporting events of their day, drawing crowds from 25,000 to over 250,000. Sections of the race were held on North Hempstead public roads. (Courtesy of Helck family collection.)

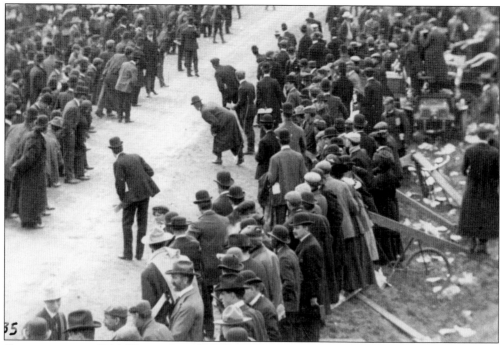

CROWDS AT THE 1904 VANDERBILT CUP RACE, WESTBURY. Near the end of the race, restless spectators venture dangerously onto Jericho Turnpike near the grandstand, searching for the remaining approaching cars. (Courtesy of Helck family collection.)

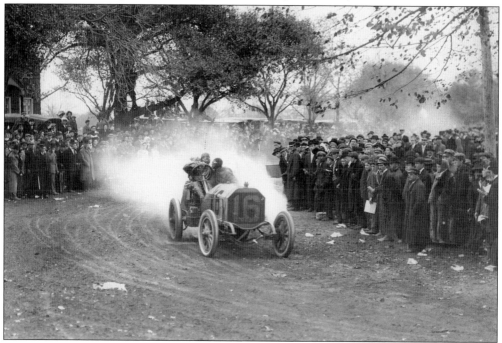

"OLD 16" AT THE 1908 VANDERBILT CUP RACE, WESTBURY. The first American car to win the Vanderbilt Cup Race was a Bridgeport-built Locomobile, driven by George Robertson. "Old 16" is taking the turn from Jericho Turnpike on to Ellison Avenue as crowds line the course.

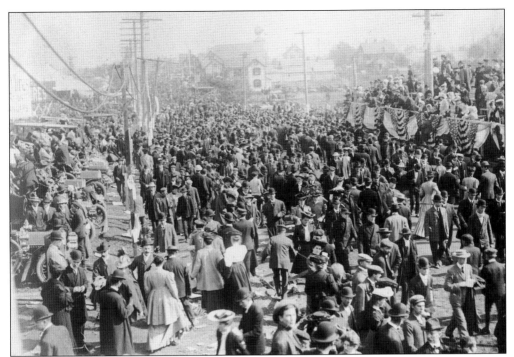

JERICHO TURNPIKE AFTER A VANDERBILT CUP RACE, OCTOBER 14, 1905. After the first cars finished the race, people swarmed onto Jericho Turnpike around the Mineola grandstand (right). Over 100,000 people watched the race, with 14 miles of the 28.3-mile course on North Hempstead roads. (Courtesy of Brown Brothers.)

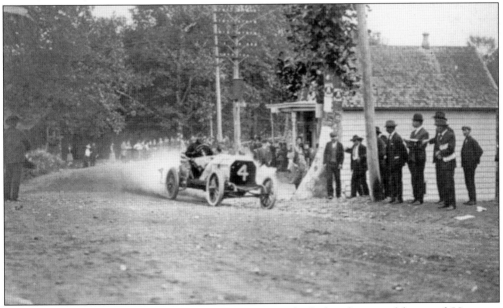

VANDERBILT CUP RACE, MANHASSET, OCTOBER 6, 1906. An Italian favorite of the crowd, Vincenzo Lancia (1881–1937) maintained the speed of his Fiat going up the difficult one-and-a-half-mile steep upgrade on North Hempstead Turnpike. Lancia would later go on to establish his own automobile company, which is still operating as part of Fiat today. (Courtesy of Brown Brothers.)

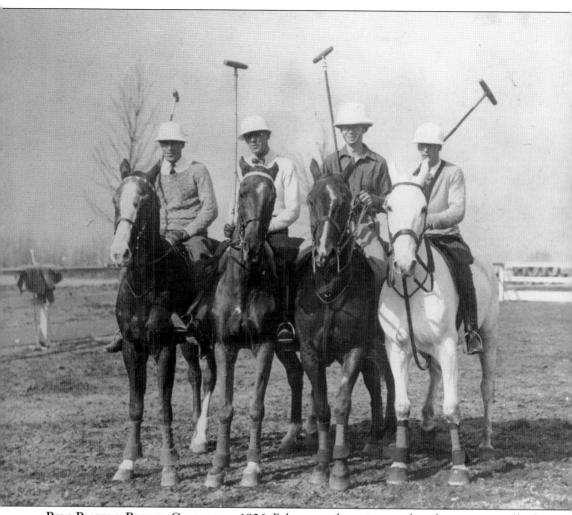

POLO PLAYERS, RUSSELL GARDENS, C. 1926. Polo was and continues to be a favorite sport of high society. Prior to World War II, local teams from Great Neck, Sands Point, and Old Westbury would compete throughout the town. These four polo players from Russell Gardens were defending their home turf, located on the corner of Melborne and Merrivale Roads. (Courtesy of Village of Russell Gardens.)

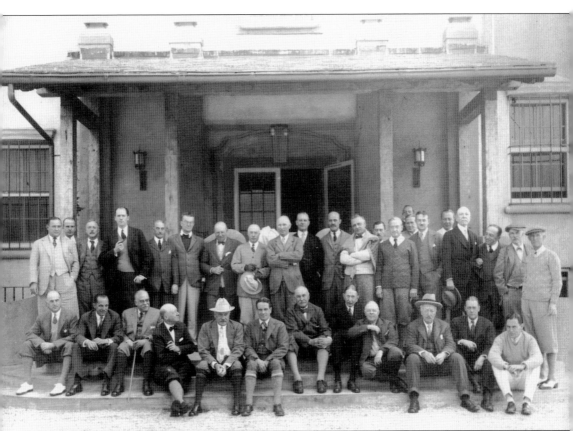

DEEPDALE CLUB, LAKE SUCCESS, 1926. Golf has always been a favorite pastime in North Hempstead, with its rolling hills and open fields. In 1924, William K. Vanderbilt Jr., avid sportsman and heir to a transportation fortune, used some of his Lake Success property to build his own private golf course. He sold it in 1928. Vanderbilt (sixth from the left in the first row) and his friends pose in front of the clubhouse at the Deepdale Club before a tournament. When the Long Island Expressway was routed through the course in 1954, Deepdale Golf Club was moved to the former W.R. Grace Estate in nearby North Hills. The clubhouse was incorporated into the Lake Success village hall and community center. (Courtesy of Suffolk County Vanderbilt Museum.)

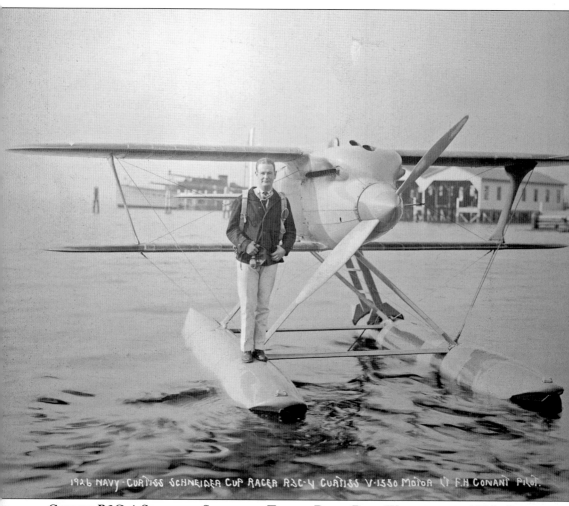

1926 NAVY - CURTISS SCHNEIDER CUP RACER R3C-4 CURTISS V-1550 MOTOR LT F.H. CONANT PILOT.

CURTISS R3C-4 SEAPLANE, SCHNEIDER TROPHY RACE, PORT WASHINGTON, 1926. Curtiss Aeroplane and Motor Co. tested its racing seaplanes in Manhasset Bay. Lt. F.H. Conant poses with the Navy version of a Curtiss racer that competed in the 1925 Schneider Trophy seaplane race at the Chesapeake Bay. The Army version of this plane won the race, with Lt. James Doolittle piloting. Both planes were powered by 565-horsepower Curtiss V-1400 engines. (Courtesy of Cradle of Aviation.)

SARAH HUGHES, GREAT NECK, 2002. Sarah Hughes returned home to one of largest parades ever held on Long Island after winning the Olympic gold medal for figure skating in Salt Lake City. The parade, on March 10, 2002, ended with a ceremony at Great Neck North School, where Hughes celebrated with classmates, family, friends, and thousands of residents. (Photograph by Bruce Cotler; courtesy of Globe Photos, Inc.)

Best Athlete

Carole Smith

Jim Brown

JIM BROWN, 1953. Jim Brown, a 1953 graduate of Manhasset High School, is considered one of the greatest US athletes of all time and probably the best all-around athlete in Long Island history. He is seen here in the Manhasset High School yearbook. He garnered 13 sports letters in football, lacrosse, basketball, baseball, and track, while averaging an amazing 14.9 yards per carry in his senior year. Brown went on to star in football, basketball, and lacrosse at Syracuse University, and he was a hall-of-fame running back in nine record-breaking years with the Cleveland Browns. In 2002, he was named the "greatest professional football player ever" by the *Sporting News.* (Courtesy of Manhasset Public Library.)

JIM BROWN ATHLETIC FIELD, MANHASSET, APRIL 27, 2013. In recognition of his athletic accomplishments, a reconstructed artificial turf field was named to honor Jim Brown. Friends, family, and town and county officials were on hand to help Brown cut the traditional ribbon.

Six

Rich and Famous

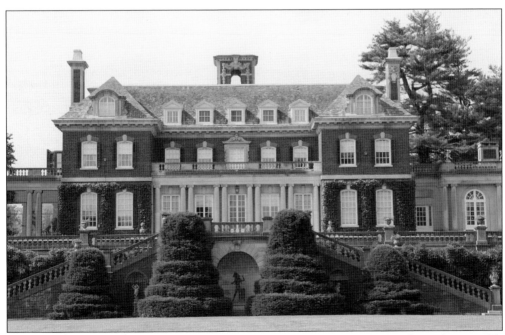

Old Westbury Gardens, Old Westbury. The former home of John Shaffer Phipps (1874–1958), Margarita Grace Phipps, and their four children is a stunning Charles II–style mansion originally on 200 acres of landscaped grounds, gardens, and ponds. Completed in 1906, this 23-room mansion is still considered the grandest house in North Hempstead. In 1958, the Phipps' children arranged to have the house and 70 surrounding acres converted to public use.

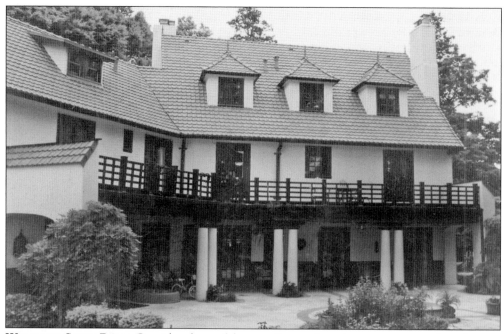

WILDBANK, SANDS POINT. Considered one of the most famous American composers and conductors, John Philip Sousa (1854–1932) lived in this waterfront Sands Point house from 1915 to 1932. Built in 1905 and listed in the National Register of Historic Places in 1966, the house remains a private residence. (Courtesy of Irmgard Carras, PhD, Village of Sands Point historian.)

JOHN PHILIP SOUSA, SANDS POINT, 1919. On December 25, 1896, Sousa composed *The Stars and Stripes Forever*, the official march of the United States of America. He was the leader of the US Marine Band from 1880 until 1892, and he invented the sousaphone. He is seen here with his daughter Jane Sousa and their dog, Toby. (Courtesy of Sousa Archives and Center for American Music, University of Illinois at Urbana-Champaign.)

ALVA VANDERBILT BELMONT, C. 1920.
Belmont (1853–1933) was a prominent
socialite and a leader in the women's
suffrage movement. In 1895, after 20 years
of marriage, she divorced William Kissam
Vanderbilt, the grandson of transportation
tycoon Cornelius Vanderbilt. Less than one
year later, she married family friend Oliver
Hazard Perry Belmont, the son of financier
August Belmont Sr. (Courtesy of Wikipedia.)

BEACON TOWERS, SANDS POINT, C. 1925.
In 1917, Alva Belmont, widowed from her
second husband, O.H.P. Belmont, for nine
years, commissioned this Gothic fantasy
castle. In 1927, she sold Beacon Towers
to the newspaper tycoon William Hearst.
Then, five years later, and only 30 years
after being built, this beautiful mansion was
destroyed. (Courtesy of UCLA Department
of Geography, Benjamin and Gladys Thomas
Air Photo Archives, the Fairchild Collection.)

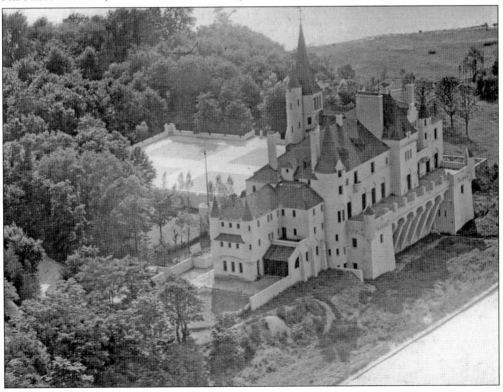

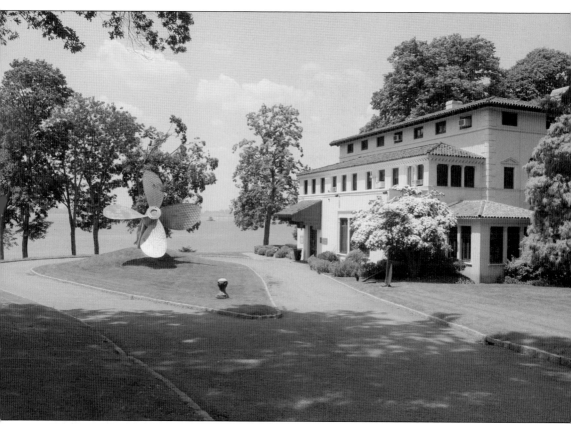

BARSTOW HOUSE, KINGS POINT. This house was built in 1910. It was expanded in 1929–1930 for William Slocum Barstow (1866–1942). The home's design was influenced by 16th-century Lombard and Tuscan architecture. Barstow, a friend of Thomas Edison, started his own engineering company in 1901. He went on to invent the electric meter that is still used today to measure electrical usage. After Barstow's death, his wife stayed on until she died in 1953. The property was sold to Frederick Lundy, owner of Lundy's Restaurant in Sheepshead Bay, Brooklyn. In 1975, it was purchased by the US Merchant Marine Academy Alumni Association, which gave it to the US government three years later. Currently the home of the American Merchant Marine Museum, it is open to the public for special exhibits. The structure in front of the house is a World War II P-2 Class troopership propeller. It stands 20.5 feet tall and weighs 19 tons.

ESTATE OF GEORGE M. COHAN AND WALTER ANNENBERG, KING POINT. This 17-room villa was built in 1915 for songwriter, playwright, and producer George M. Cohan (1878–1942). The three-story house was originally part of a 10-acre property with water frontage. In an interview, Cohan (at right) said, "I bought a lovely home in the theatrical colony in Great Neck, Long Island, a dream place where I thought inspiration would strike me. I put on paper in my Great Neck home the start of one great idea, something I am more proud of than anything I have ever written . . . it's the war song *Over There*." The property was later purchased by *TV Guide* publisher and philanthropist Walter Annenberg. Following its designation as a landmark by the Village of Kings Point, the mansion was saved from demolition and remains privately held. (Right, courtesy of Town of North Hempstead Archives.)

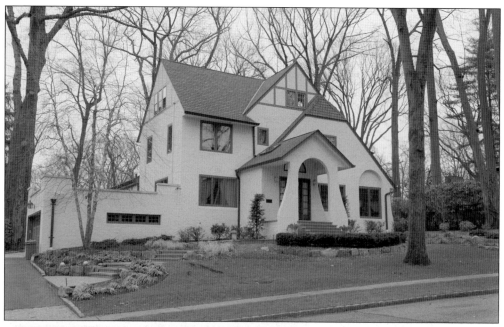

HOME OF GROUCHO MARX, THOMASTON. Reflecting its proximity to the center of the entertainment world in Manhattan, entertainment and literary figures lived throughout the villages of Great Neck. Comedian and film and television star Julius "Groucho" Marx (1890–1977) purchased this house in 1929 while appearing in Broadway shows and movies filmed in New York. After starring in *The Cocoanuts* and *Animal Crackers*, he sold his first home and moved with his brothers to California to pursue their Hollywood careers. He and the other Marx brothers made 15 feature films, several of which are considered classic comedies. Groucho was known as a master of wit and for his distinctive greasepaint moustache, eyebrows, glasses, and cigar. He also enjoyed a successful solo career as the radio and television host of the long-running game show *You Bet Your Life*. (Left, courtesy of Town of North Hempstead Archives.)

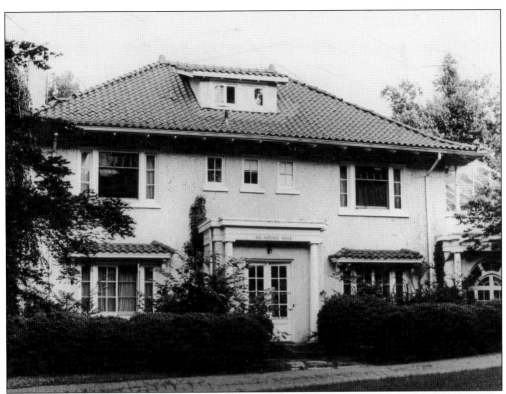

GREAT NECK ESTATES, HOME OF F. SCOTT FITZGERALD. Author F. Scott Fitzgerald (1896–1940), his wife, Zelda (1900–1948), and their daughter, Scottie (Frances Scott, 1921–1986), lived in the house above on Gateway Drive from October 1922 to April 1924. Here, he refined drafts for his great novel *The Great Gatsby*. He would later finish the book in Paris in 1925 when he was only 28 years old. He is widely considered one of the greatest American writers of his era. The Fitzgeralds are seen right dancing while in Paris in December 1925. (Right, courtesy of Hulton Archive/Getty Images.)

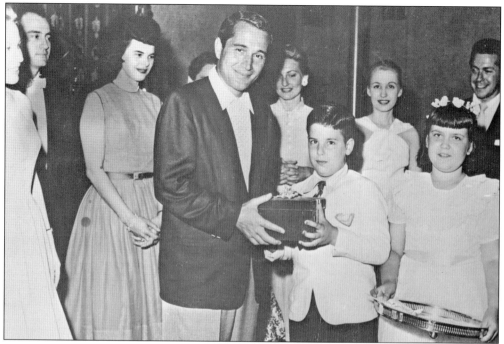

PERRY COMO, ST. FRANCIS HOSPITAL, FLOWER HILL, C. 1958. Founded in 1922 by the Franciscan Missionaries of Mary, St. Francis Hospital has received worldwide recognition for its patient care. Singer and television personality Perry Como, a resident of Sands Point since 1952, supported the fundraising activities of the nearby hospital for over 30 years. (Courtesy of Town of North Hempstead Archives.)

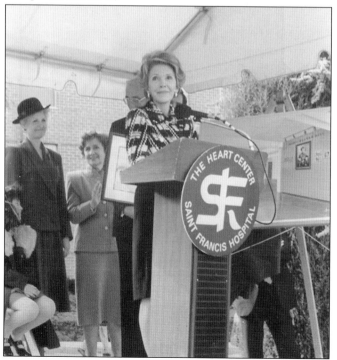

NANCY REGAN, ST. FRANCIS HOSPITAL, FLOWER HILL, DECEMBER 15, 1983. During a trip to South Korea in November 1983, Pres. Ronald Regan and First Lady Nancy Regan brought back seven-year-old Ah Ji Sook and four-year-old Lee Kil Woo for open-heart surgery. The trip and surgery was arranged by the Gift of Life program initiated by the Manhasset Rotary Club. (Courtesy of Town of North Hempstead Archives.)

HOME OF W.C. FIELDS, RUSSELL GARDENS. While appearing in the Earl Carroll's Vanities on Broadway in 1928, Fields rented this Tudor home on Dunster Road. The Vanities was cowritten by Fields and directed and produced by Earl Carroll, with choreography by Busby Berkeley. Below, Fields is seen in character in 1925 for the filming of D.W. Griffith's *Sally and the Sawdust*. The movie was shot in Russell Gardens and on the Long Island Motor Parkway in Lake Success.

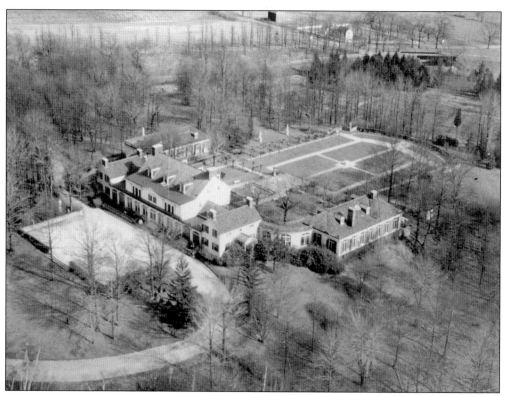

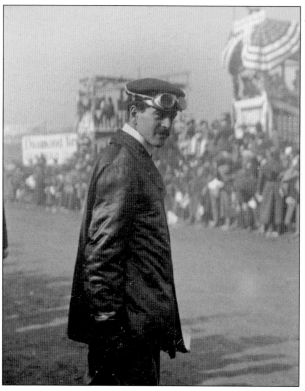

Deepdale Estate, Lake Success, 1927. The former home of William K. Vanderbilt Jr. (1878–1944), pioneering race-car driver and heir to a transportation fortune, was located south of the lake. Although reduced in size, today Deepdale remains a private residence. Vanderbilt, seen at left in Mineola in 1905, was the referee of four Vanderbilt Cup Races, held in sections of North Hempstead (1904, 1905, 1906, and 1908). (Above, courtesy of UCLA Department of Geography, Benjamin and Gladys Thomas Air Photo Archives, the Fairchild Collection.)

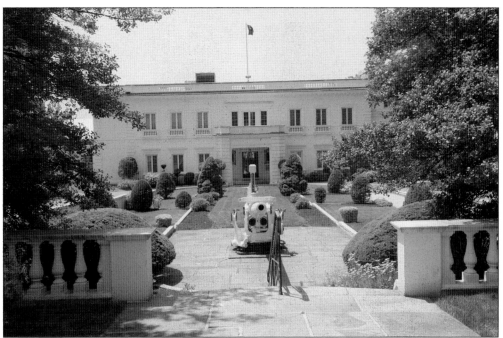

FORKER HOUSE/WILEY HALL, KINGS POINT. This Beaux-Arts version of a French Renaissance–style mansion was originally built in 1917 for retailer Henri Bendel (1868–1936). It was sold in 1923 to automobile industry executive Walter P. Chrysler (1875–1940), who used it as a summer home until his death. The original Chrysler estate included 12 acres, 450 feet of water frontage, a sunken garden in front of the portico facing the waterfront (below), and outdoor and indoor swimming pools. As seen above, the house was originally approached along a drive lined with formal gardens. The house was acquired by the US government in 1942 for $100,000 (equivalent to $13.9 million today). After initial use for classroom and dormitory space, the mansion became the main administration building of the US Merchant Marine Academy.

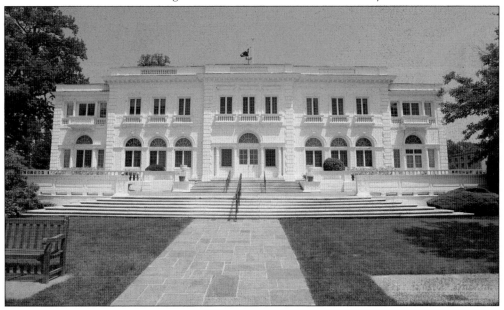

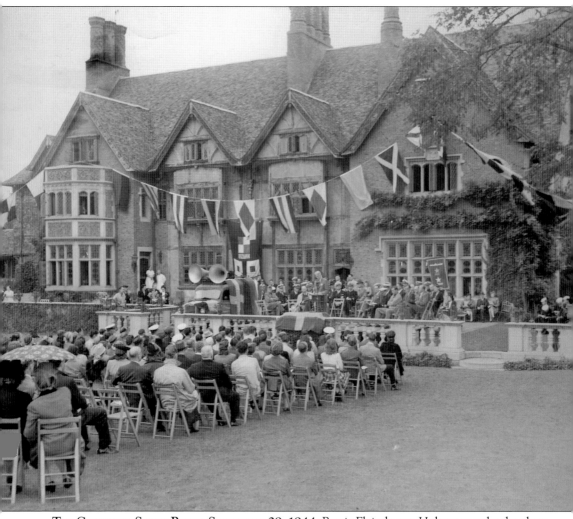

THE CHIMNEYS, SANDS POINT, SEPTEMBER 29, 1944. Bettie Fleischman Holmes was the daughter of Charles Fleischman, owner of the Fleischman Yeast Company. In 1930, she and her husband, Dr. Charles Holmes, built a 42-room Tudor mansion at a cost of $3 million ($40.8 million today). The home included central air-conditioning, vacuum systems, and built-in fire hoses. Reflecting its name, every major room in the mansion had its own fireplace. In this photograph, the mansion is being dedicated as a rest center for American merchant seamen under the joint operation of the United Seaman's Service and the War Shipping Administration. Since 1954, the mansion has served as the Sands Point Community Synagogue.

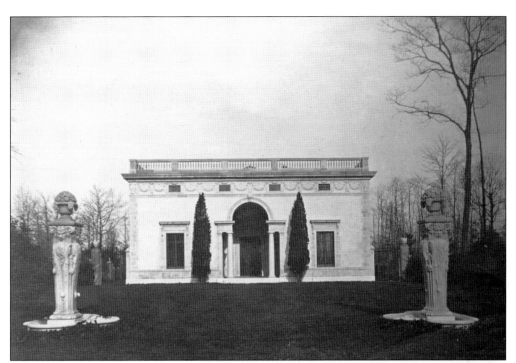

GERTRUDE VANDERBILT WHITNEY ART STUDIO, OLD WESTBURY, C. 1928. This art studio was built in 1913 by Delano & Aldrich sculptor and art patron Gertrude Vanderbilt Whitney (1875–1942), wife of Harry Payne Whitney (1872–1930). Gertrude Whitney reportedly wanted the art studio in the woods to get away from her husband's polo-playing friends. The great-granddaughter of Corneilius Vanderbilt, she was the founder of the Whitney Museum of American Art in New York City in 1930. Today, the house is a private residence. (Both, courtesy of Bryant Library.)

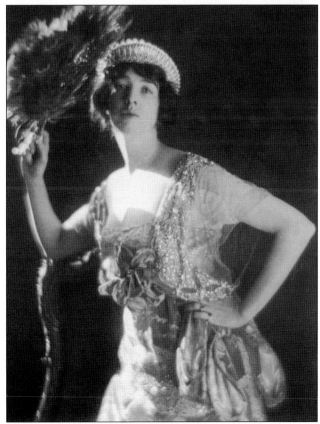

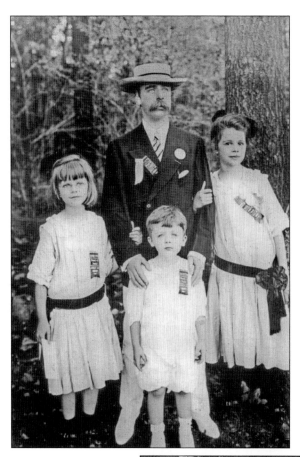

CLARENCE MACKAY AND HIS CHILDREN, JULY 4, 1911. Clarence H. Mackay (1874–1938) was heir to the Comstock lode silver fortune and was a major figure in the development of the international telegraph business. Here, he poses with his children at a Roslyn Board of Trade Fourth of July party. From left to right are Ellin, Clarence, John William, and Katherine "Kay." The children are wearing Roslyn Board of Trade badges. (Courtesy of Trinity Episcopal Church.)

HARBOR HILL ESTATE, ROSLYN, 1920. Among the largest estates ever built on Long Island, the Renaissance-style Harbor Hill mansion was designed in 1899 by Stanford White and built in 1900–1902 for financier Clarence H. Mackay (1874–1938) and his wife, Katherine. In this aerial photograph, two 26-foot granite replicas of the famous French Marly Horse statues are being installed at the end of the west gardens.

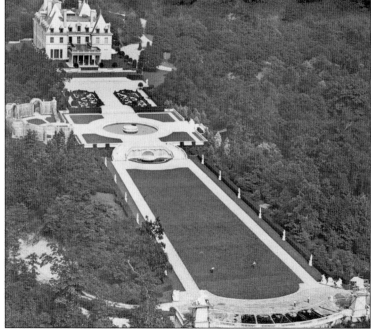

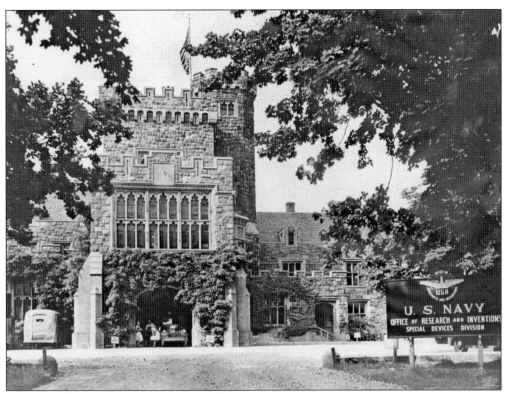

GOULD CASTLE /HEMPSTEAD HOUSE, SANDS POINT, C. 1950. Originally built for financier Howard Gould (1871–1959) in 1909, this 40-room English Tudor mansion became the home of mining industrialist Daniel Guggenheim (1856–1930) and his wife, Florence, in 1917. After Daniel Guggenheim passed away, his wife gave the buildings and 162 acres to The Institute of Aeronautical Sciences. From 1946 to 1967, the Special Devices Division of the Navy used the property for the design of electronic systems. In 1971, Nassau County acquired 127 acres for recreational use. Currently, Hempstead House is operated for special events as part of the Sands Point Preserve by the Nassau County Department of Parks, Recreation, and Museums. (Both, courtesy of Cradle of Aviation.)

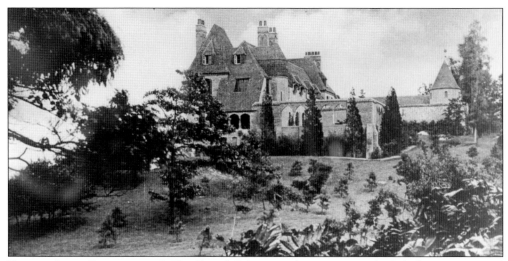

FALAISE, SANDS POINT, C. 1935. This French Eclectic–style mansion was built for businessman and philanthropist Harry Guggenheim (1890–1971) and his wife, Caroline Morton, in 1923 and modeled on a 13th-century Norman manor house. He and his third wife, Alicia Patterson (1906–1963), established *Newsday* in 1940. After Guggenheim died in 1971, the 90-acre estate became part of Nassau County's Sands Point Preserve. (Courtesy of Town of North Hempstead Archives.)

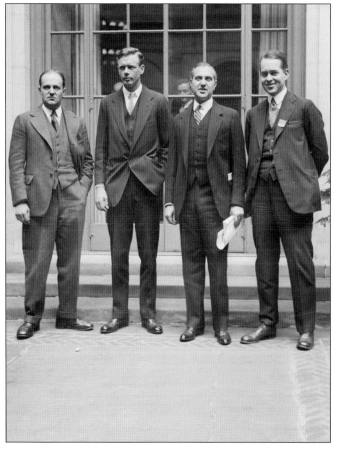

COL. CHARLES LINDBERGH AND HARRY GUGGENHEIM, WASHINGTON, DC, DECEMBER 12, 1928. Guggenheim (second from left) had a lifelong interest in aviation and was a close friend of Charles Lindbergh (second from left). While a guest at Falaise, Lindbergh wrote most of his autobiography *We.* Guggenheim was instrumental in getting funding for the rocket research of pioneer Robert Goddard. These men are gathered at the opening session of the International Civil Aeronautics Conference in Washington, DC. From left to right are F. Trubee Davison, assistant secretary of War for Aviation; Lindbergh; Guggenheim; and Edward T. Warner, assistant secretary of the Navy for Aviation. (Courtesy of Library of Congress.)

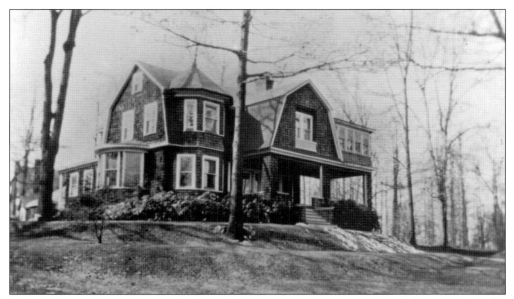

GREEN ESCAPE, HOME OF CHRISTOPHER MORLEY, ROSLYN ESTATES. Author Christopher Morley (1890–1957) moved to this Roslyn Estates home in 1920. Morley was one of the founders and a contributing editor for the *Saturday Review of Literature,* editor of *Bartlett's Familiar Quotations,* and author of more than 100 books, essays, poems, and novels. In 1961, a 98-acre Nassau County park in North Hills was named in his honor.

CHRISTOPHER MORLEY'S KNOTHOLE, NORTH HILLS. This one-room cabin was used by Christopher Morley as his studio at his Roslyn Estates home. Constructed in 1934, the Knothole includes built-in bookshelves, a fireplace, a bunk bed, and a modular "dymaxion" bathroom designed by Morley's friend Buckminster Fuller. The Knothole was moved to Christopher Morley Park by his friends and neighbors as a memorial to the prominent writer, to keep his spirit alive.

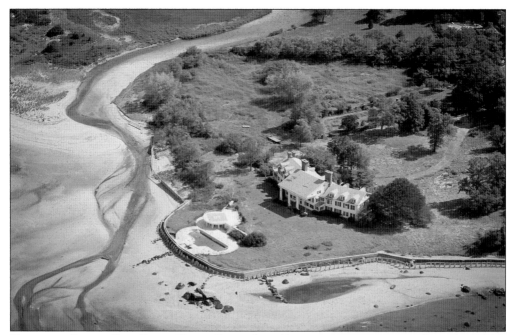

KEEWAYDIN/LANDS END, SANDS POINT. Located on 13 acres on its own peninsula, with a 1,700-square-foot waterfront, this 25-room, 20,000-square-foot Colonial Revival mansion was considered by some to be the inspiration for Daisy Buchanan's East Egg home in *The Great Gatsby*. The house was originally built for clothier John Scott Browning in 1912 and named Keewaydin. It was purchased in 1929 by publisher Herbert Bayard Swope (1882–1958), who lived there until his death. After having several owners, it was purchased by financier Charles Shipman Payson in 1983, who renamed it Lands End. After being sold to a developer in 2004, the house became dilapidated and was demolished in 2011. A subdivision of the property has been approved by the Village of Sands Point for five new residences. (Above, courtesy of John Meehan; below, courtesy of Natasha Walia Commander.)

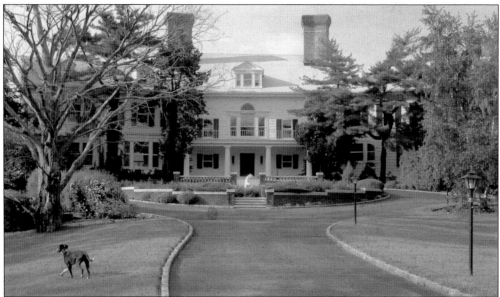

Seven

LANDMARKS

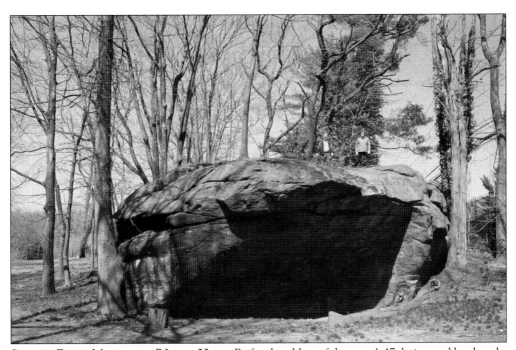

SHELTER ROCK, MANHASSET/NORTH HILLS. By far the oldest of the town's 17 designated landmarks is the largest glacial boulder on Long Island. Geologists believe this granite boulder was deposited from across the Long Island Sound by an ice sheet over 10,000 years ago. Town historian Howard Kroplick (left) and town clerk Leslie Gross (right) paid a visit to the 55-foot-high Shelter Rock in 2013. (Courtesy of John Meehan.)

THOMAS DODGE HOUSE, PORT WASHINGTON, 1925. Built in 1721, this is probably the oldest house in Port Washington. It functioned as a working farm for 180 years. Here, seven generations of Dodges lived, raised sheep and hogs, grew flax, and sold wool, linen, and meat. The Cow Neck Peninsula Historical Society opened this house to the public as a museum in 1993. (Courtesy of Nassau County Department of Museum Services.)

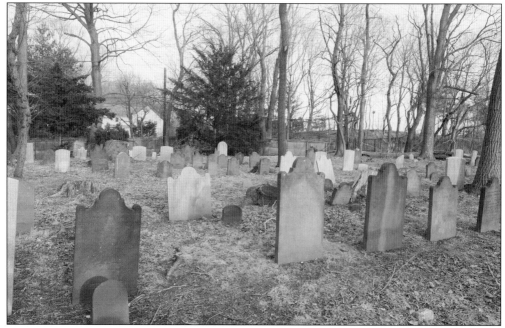

MONFORT CEMETERY, MANHASSET. This burial ground contains 118 headstones of the earliest Dutch settlers of North Hempstead and their families, buried from 1737 to 1892. Originally part of the 110-acre Rapelje farm, this one-acre property was sold in July 1786 to members of the Onderdonk, Schenck, Hegeman, and Dodge families. Burtis Monfort transferred ownership of the cemetery in 1984 to the Town of North Hempstead.

DUTCH HOMESTEAD, SEARINGTOWN. Built around 1740, this home was originally located in Flushing and was moved to Searingtown after 1925. The house is an excellent example of the Colonial Revival style once fairly common on Long Island. It may be one of the only of its type to survive. Restored by the Sackler and Magid families, the home remains as a private residence. (Courtesy of Town of North Hempstead Archives.)

SCHUMACHER HOUSE, NEW HYDE PARK. This homestead was built in Lake Success around 1750 for the prominent Cornell family. When Sperry was the temporary headquarters for the United Nations between 1946 and 1951, the house was a nursery school for the children of UN personnel. In 1951, the house was moved from Lake Success to its current location in New Hyde Park. (Courtesy of Town of North Hempstead Archives.)

LAKEVILLE A.M.E. CHURCH AND CEMETERY, MANHASSET. This African Methodist Church was originally organized in 1820, when religious leaders brought their congregation from Flushing to settle in the community along Valley Road, now Community Drive. The church was built in 1833 from land purchased from Rev. Anthony Treadwell, and it quickly became the epicenter of the area called Success. The cemetery contains the graves of former slaves, freed men and women, and Matinecocks. Descendants of the founders of the community and the church still live in the area. (Courtesy of Town of North Hempstead Archives.)

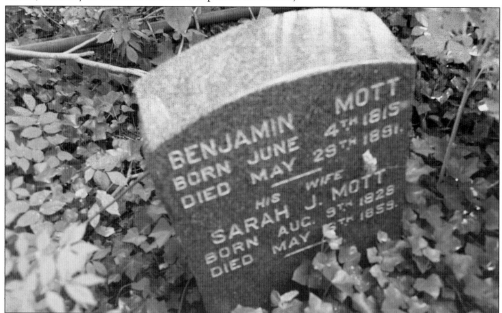

BENJAMIN MOTT CEMETERY, GLENWOOD LANDING. In 1751, Jacob Mott purchased the "lower Mott Farm," which included much of present-day Glenwood Landing. This cemetery was located on the farm. From around 1822 to 1935, a total of 34 members of the Mott family were buried here, including Jackson Mott's grandson, Stephen Mott. He was captain of the steamship *Idlewild*, which regularly sailed from present-day South Street Seaport in Manhattan to Glenwood Landing.

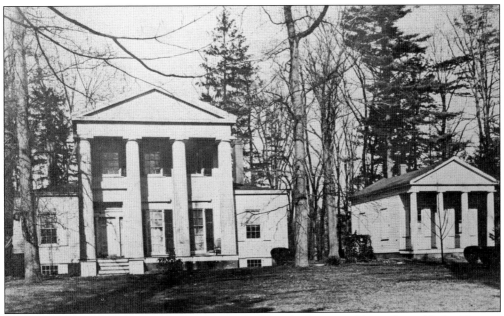

ONDERDONK HOUSE, MANHASSET, C. 1900. This was the home and law office of Judge Horatio Gates Onderdonk (1808–1886), who was a county judge for Brooklyn. Built in 1836, it is considered one of Long Island's finest examples of Greek Revival architecture. The building and surrounding property were sold by the Onderdonks to Levitt & Sons in 1933. The building is now owned by the Strathmore Association. (Courtesy of Town of North Hempstead Archives.)

EAST GATE TOLLHOUSE, GREENVALE. This one-and-a-half-story batten board building was erected in 1850 for the Flushing-North Hempstead Toll Road Company as a tollhouse and toll-keeper's residence for Northern Boulevard. A long pole was extended over the road by the toll keeper until the $1.50 six-month toll was collected. It is the only surviving 19th-century tollhouse on Long Island.

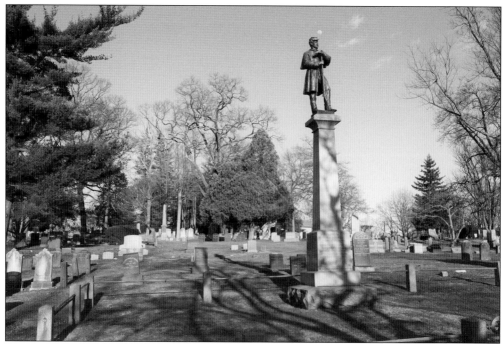

ROSLYN CEMETERY, GREENVALE. Founded around 1860, this burial ground was a result of the Rural Cemetery Act, which sought to combine cemeteries and parks. Several prominent people are buried here, including William Cullen Bryant (1794–1878, monument seen here); journalist, novelist, and poet Christopher Morley (1890–1957); and author Frances Hodgson Burnett (1849–1924), who wrote *Little Lord Fauntleroy*, *A Little Princess*, and *The Secret Garden*. (Courtesy of Bryant Library.)

ROSLYN HOUSE/WARMUTH HOUSE, ROSLYN. This former saloon/country hotel was built for John Warmuth in 1870. It was located in the Round Hill section of Roslyn Heights, which developed shortly after the arrival of the Long Island Rail Road in 1865. Over time, it has served as a residence, ice-cream parlor, luncheonette, and, most recently, offices for architects. (Courtesy of Town of North Hempstead Archives.)

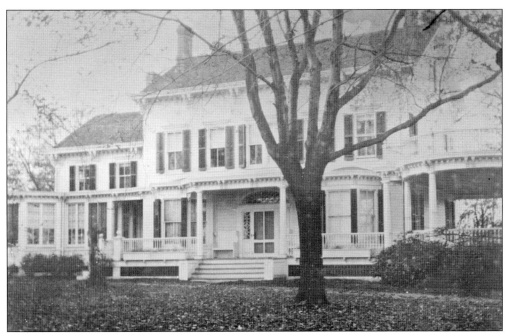

DENTON HOUSE, NEW HYDE PARK. This building, originally a 1795 farmhouse and renovated in 1865, was built for Charles Denton, who was a descendant of Rev. Richard Denton, one of the founders of the town of North Hempstead. The house was designed in the Georgian style, with a five-bay, two-story center hall with Italianate detailing on the exterior. After being sold by the Denton family, the building was used for a variety of restaurants until a fire in 1983. McDonald's acquired the property in 1985 with the intention of demolishing the dilapidated building. Following designation of the building as a historic landmark by the Town of North Hempstead and Village of New Hyde Park, McDonald's agreed to restore the structure to its 1926 appearance. It is considered by many architects to be the most beautiful fast-food restaurant in the United States. (Above, courtesy of Town of North Hempstead Archives.)

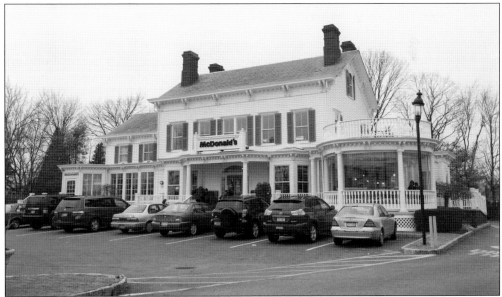

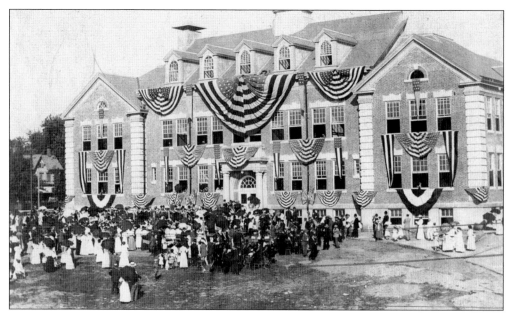

MAIN STREET SCHOOL, PORT WASHINGTON. The opening of this school in the center of the village was celebrated on September 17, 1909, with hundreds of schoolchildren parading down Main Street accompanied by three marching bands. Built over two years, the school represents the Georgian Colonial style, laid out in Beaux-Arts fashion. Active as a school until 1985, it is the only civic building on Long Island to receive national landmark status. Today, it is known as "Landmark on Main Street" and is used as a community center, a senior center, a day care center, and a theater. (Courtesy of Port Washington Library.)

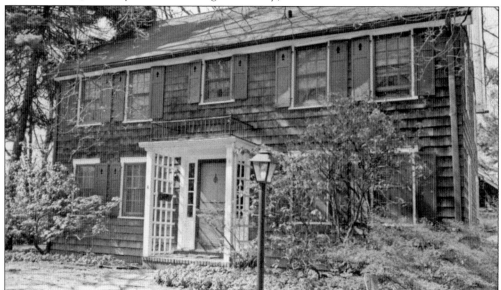

JOHN L. MILLER RESIDENCE, GREAT NECK. Built in 1925, this home was the residence of John L. Miller, superintendant of the Great Neck School district for 28 years (1942–1970). Miller's policies brought national attention to the school district. In appreciation of his efforts, in 1970, Great Neck North Senior High School was renamed the John L. Miller-Great Neck North High School. (Courtesy of Town of North Hempstead Archives.)

PORT WASHINGTON HEIGHTS HISTORIC DISTRICT. Port Washington's first commuter subdivision was built following the arrival of the Long Island Rail Road in the village in 1898. The district of 44 homes remains virtually intact from its development period, retaining a high degree of integrity of setting, design, and craftsmanship. Styles include a variety of Colonial and Tudor Revivals. It is located west of the Port Washington Long Island Rail Road line, south of Main Street, and east of Plandome Road. This historic district was designated by the town board on January 11, 1994.

Roslyn Heights Historic District. This cohesive neighborhood of 77 homes was predominantly built in the late 1800s and early 1900s. The residents sought historic district designation to preserve the "Norman Rockwell" character and small-village atmosphere. Colonial Revival is the predominant architectural style. However, the district includes a wide range of styles, including Victorian/Queen Anne, Tudor Revival, Prairie, American Foursquare, and Craftsman. Located between Willis Avenue and the Roslyn Long Island Rail Road station, the district was designated by the town board on January 5, 1999.

Eight

THEN AND NOW

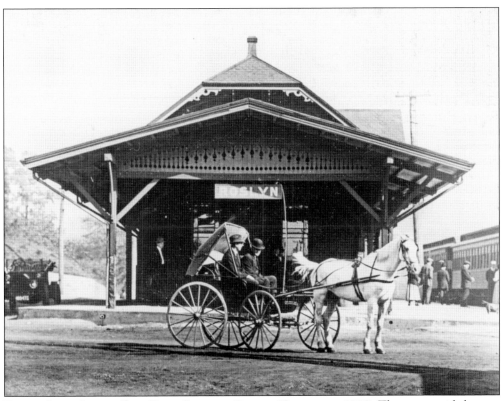

ROSLYN LONG ISLAND RAIL ROAD STATION, ROSLYN HEIGHTS, C. 1908. The most rapid changes in North Hempstead occurred at the turn of the 20th century. Advances in transportation changed how people worked and lived, as horsepower was replaced by the train and then by the automobile. The original Roslyn station was built in 1865. It was rebuilt in 1887 and relocated and restored in 1988. (Courtesy of Ian Zwerdling.)

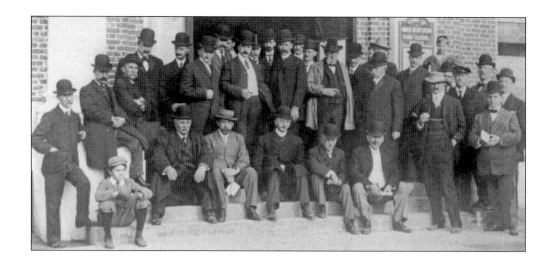

NORTH HEMPSTEAD TOWN HALL, 1907 AND 2007. In the above photograph, town officials, community leaders, and politicians pose in front of the newly opened hall in 1907. The sign reads "Town of North Hempstead, Town Clerk's Office." Philip J. Christ, the town supervisor, is sitting in the center of the first row. His son Marcus Christ is the youngster sitting on the step at left. Marcus Avenue was eventually named for him. Below, at the centennial celebration of the building in 2007, town officials repeated the 1907 pose. Town supervisor Jon Kaiman is sitting on the first step (third from right), and his son Jared Kaiman is the youngster on the left. (Both, courtesy of Town of North Hempstead Archives.)

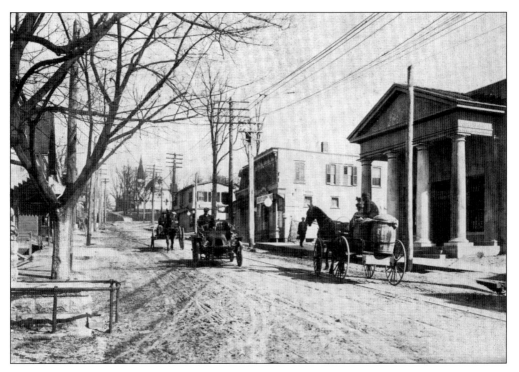

MAIN STREET, PORT WASHINGTON, C. 1909 AND 2013. The 1909 view looking west shows the Bank of North Hempstead to the right. The First Methodist Church is in the background. Horse carriages still dominated the road. The current view (below) shows that a restaurant has replaced the bank and the Port Washington Public Library was built on the site of the church, which relocated to Sands Point in 1967. (Above, courtesy of Nassau County Department of Museum Services.)

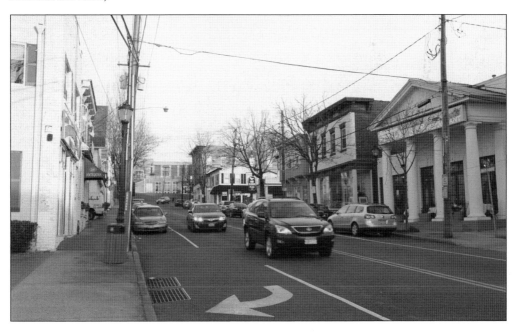

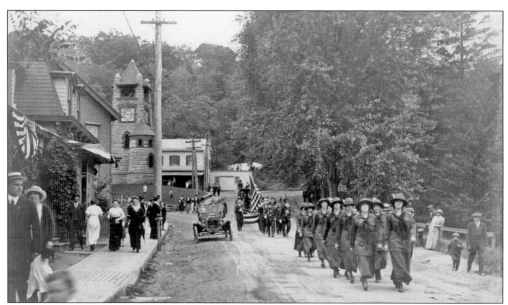

MAIN STREET, ROSLYN, 1914 AND 2013. The Girl Pioneers, a precursor to the Girl Scouts, was a local Roslyn group founded by community activist Grace Hicks. The aim of the organization was "to develop good citizenship by making girls healthier and happier, by cultivating in them virtues of simple living, and instilling in them an enthusiasm for efficient work and joyous recreation." They participated in many cultural, civic, and charitable events. In 1914, the Girl Pioneers were marching east in a Memorial Day parade (above) to the Roslyn Cemetery ahead of a group of Grand Army of the Republic Civil War veterans. Today, after almost 100 years, several buildings on Main Street and the Roslyn Clock Tower remain. The tower was given to the community in 1895 by the children of Ellen Ward as a memorial to their mother. (Above, courtesy of Bryant Library.)

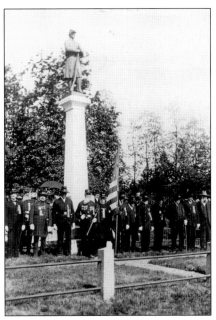

CIVIL WAR VETERANS AT ROSLYN CEMETERY, GREENVALE, 1915. Following the Civil War, organizations of veterans such as the Grand Army of the Republic (GAR) came together, first for fellowship and then for political power. Every May on Declaration Day (Memorial Day), Roslyn's GAR Post No. 643 and other local civic groups would parade down Main Street in Roslyn to the GAR memorial plot in the Roslyn Cemetery. (Courtesy of Roslyn Landmark Society.)

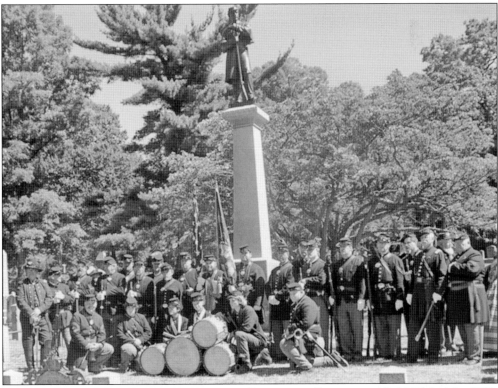

GAR CIVIL WAR MONUMENT REDEDICATION, GREENVALE, SEPTEMBER 10, 2005. In May 1992, the original 1902 statue of an infantryman was stolen by thieves from the Roslyn Cemetery. Funds were raised by the community for a replacement statue made from a similar 1866 mold. In 2005, a rededication ceremony celebrated the new statue, and reenactors once again marched up Northern Boulevard. (Courtesy of Company K, 67th New York Volunteer Infantry.)

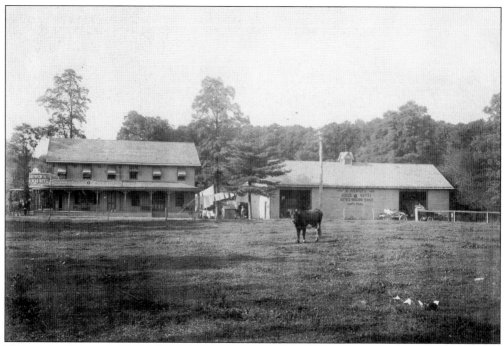

NORTHERN BOULEVARD AND GLEN COVE ROAD, GREENVALE, 1905 AND 2013. On the northeast corner of this intersection stood Aloysius Huwer's Bulls Head Hotel, a favorite inn with the town. It was so popular that many Long Islanders began to call the area Bulls Head. Adjoining the hotel was the Auto & Wagon Shed to repair and store automobiles, race cars, and horse carriages. Today, the bull in the 1905 photograph above is standing in the location of a favorite Greenvale deli (below).

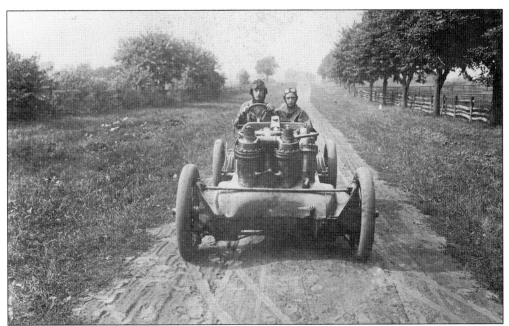

GUINEA WOODS ROAD, OLD WESTBURY, 1906 AND 2013. Practicing for the 1906 Vanderbilt Cup Race, driver Walter Christie (left) and his mechanic, Lewis Strang (right), were stopped near their Old Westbury headquarters without another car in sight. Their car, designed by Christie, was one of the first front-wheel-drive racers. Unfortunately, prior to the race, Christie clobbered a telegraph pole, and the car was replaced. Today, Guinea Woods Road is filled with cars and red-light cameras to slow down potential racers. The name *Guinea Woods* was derived from a nearby community whose descendants came from the African country of Guinea. (Above, courtesy of Richard Gauchot.)

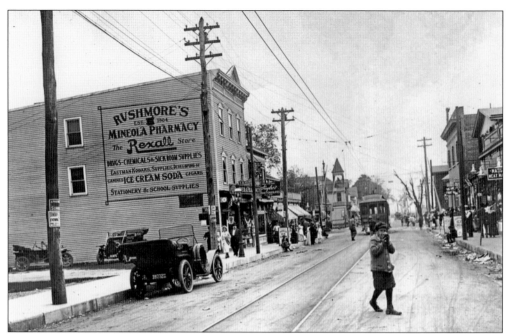

MAIN STREET MINEOLA, 1913 AND 2013. Photographer Otto Korton captured the business district of Mineola, including Rushmore's Pharmacy and a New York & North Shore Traction Company trolley. Rushmore sold postcards of this photograph to promote his business. Before ceasing operations in 1920, the trolley connected Mineola with Hicksville to the east, Port Washington to the north, and Flushing and Whitestone to the west. Today, the Rushmore building is still standing (below). The trolley tracks have been paved over. (Both, courtesy of Nassau County Department of Museum Services.)

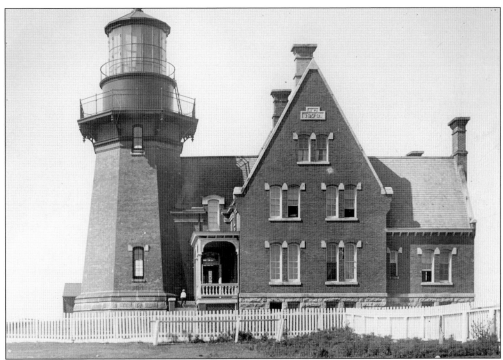

SANDS POINT LIGHTHOUSE, 1898 AND 2013. Sands Point was not named for its sandy beaches, but for the Sands family, which owned over 500 acres on the peninsula. The 51-foot lighthouse, Sands Point's best-known landmark and village symbol, was built between 1808 and 1809 to warn ships of reefs 1,500 yards north of the point. The beacon was operated by the US government from 1809 to 1922. A brick two-and-a-half-story keeper's house was built in 1868. Soon after being decommissioned, the lighthouse and keeper's house were purchased for $100,000 (equivalent to $1.3 million today) by Alva Vanderbilt Belmont and became part of her adjoining Beacon Towers estate. In 1992, the lighthouse was named an official landmark by the Historic Landmarks Preservation Commission of the Village of Sands Point. Seen below, the lighthouse and adjoining keeper's house remain privately held and are connected to the owner's recently built home. (Above, courtesy of Suffolk County Historical Society.)

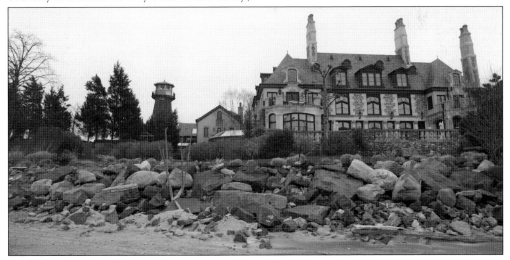

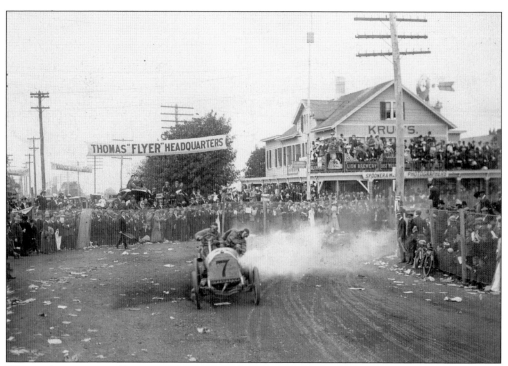

WILLIS AVENUE AND JERICHO TURNPIKE, MINEOLA, 1906 AND 2013. Over 2,500 spectators came to this "Krug's Corner" intersection to watch the 1906 Vanderbilt Cup Race. Seen in the background, Krug's Hotel served as a favorite hotel during the races and as the headquarters for the Thomas race team. Above, driver William Luttgen makes the turn in a Mercedes. Today, thousands make the turn, not realizing it was once part of a race course.

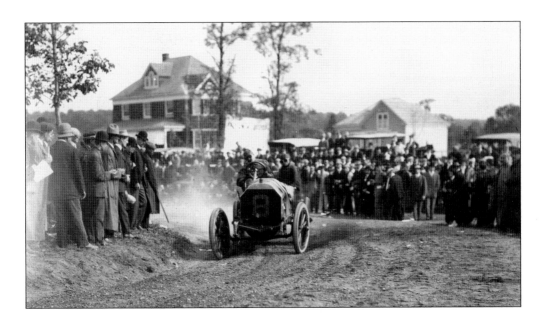

WHEATLEY ROAD AND OLD WESTBURY ROAD, OLD WESTBURY, 1906 AND 2013. An exciting vantage point for the 1906 Vanderbilt Cup Race was the "Hairpin Turn" in Old Westbury. Thousands were dangerously close to the action as Italian driver Felice Nazzaro drove his 120-horsepower Fiat at the turn before finishing sixth in the race. Below is a view of the turn as it looks today. Oddly, the shape of the turn is similar to over 100 years ago. The beautiful house in the background of the 1906 photograph still stands.

MACKAY ESTATE GATE LODGE, EAST HILLS, C. 1918 AND 2013. This French Renaissance lodge is located at the former entrance of Clarence Mackay's 648-acre Harbor Hill estate in Roslyn, now East Hills. Designed by prominent architect Stanford White, this outbuilding was erected in 1900 as a miniature version of the main house. The same stone and slate used on the mansion was used on the gate house. On April 12, 1991, the lodge was listed in the State and National Registers of Historic Places. The lodge today is currently privately owned and designated for protection by the Village of East Hills. Plans are currently being made to restore the building and transfer ownership to the Town of North Hempstead, with management by the Roslyn Landmark Society. (Above, courtesy of Bryant Library.)

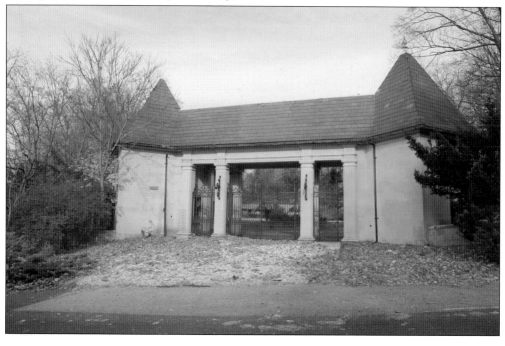

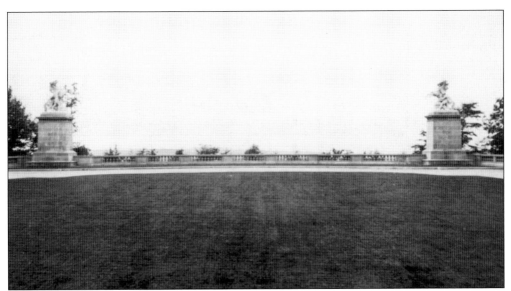

MACKAY ESTATE HORSE STATUE, EAST HILLS, C. 1927 AND 2013. In 1920, Clarence Mackay commissioned two horse tamer statues/pedestals for the west gardens of his Harbor Hill estate. Modeled after Louis XIV's Marly Horses, now on display in the Louvre, the pink marble statues/pedestals were 26 feet high and weighed over 40 tons. After the mansion was demolished in 1947, the two statues were separated; one found a home in front of the Roslyn High School, and the other remained in place, which became the backyard of a private residence. When this property was sold in 2010, this statue and pedestal were donated to the Town of North Hempstead. With assistance from the Gerry Charitable Trust, the Roslyn Landmark Society, the Town of North Hempstead, and the community, the statue has been restored and was placed in its new Roslyn home in Gerry Park on October 19, 2013. (Above, courtesy of Bryant Library.)

DISCOVER THOUSANDS OF LOCAL HISTORY BOOKS FEATURING MILLIONS OF VINTAGE IMAGES

Arcadia Publishing, the leading local history publisher in the United States, is committed to making history accessible and meaningful through publishing books that celebrate and preserve the heritage of America's people and places.

Find more books like this at
www.arcadiapublishing.com

Search for your hometown history, your old stomping grounds, and even your favorite sports team.

Consistent with our mission to preserve history on a local level, this book was printed in South Carolina on American-made paper and manufactured entirely in the United States. Products carrying the accredited Forest Stewardship Council (FSC) label are printed on 100 percent FSC-certified paper.

MADE IN THE USA